BO
DIDDLEY

GUITAR MADE BY

Bo Diddley

FOR

DICK CLARK

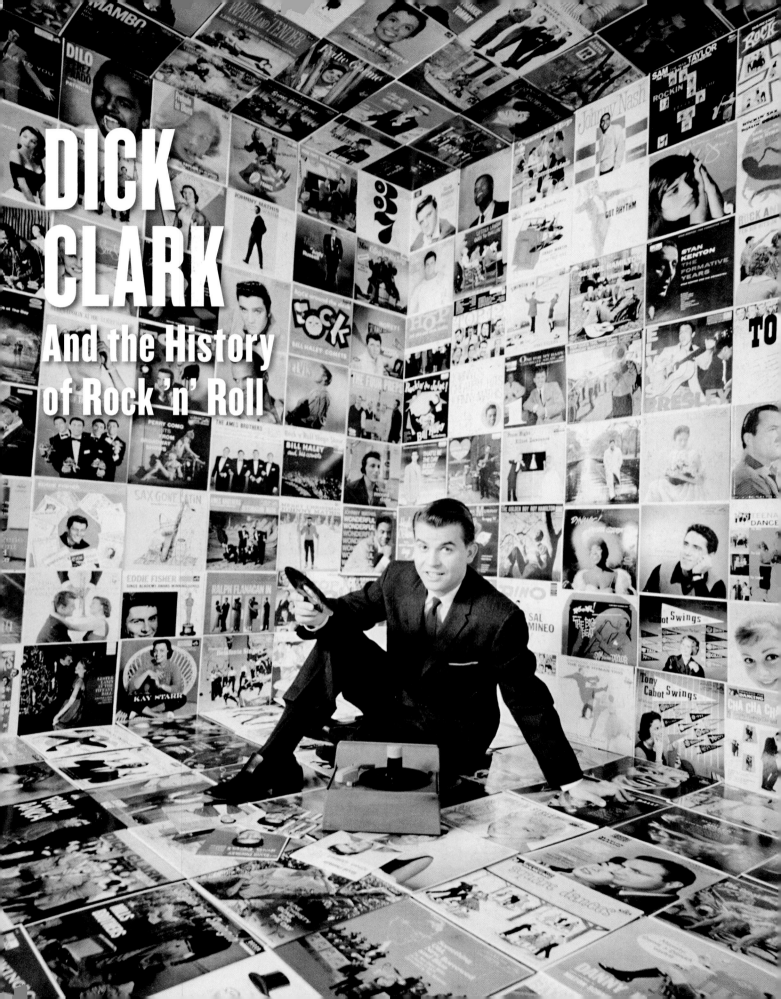

DICK CLARK
And the History of Rock 'n' Roll

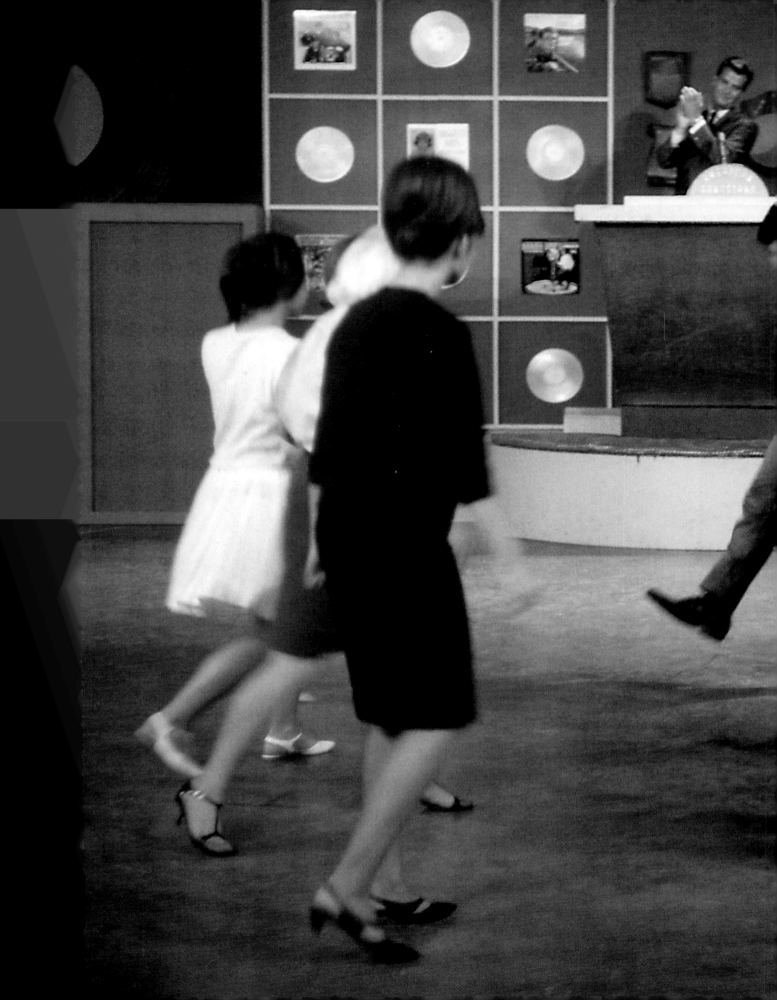

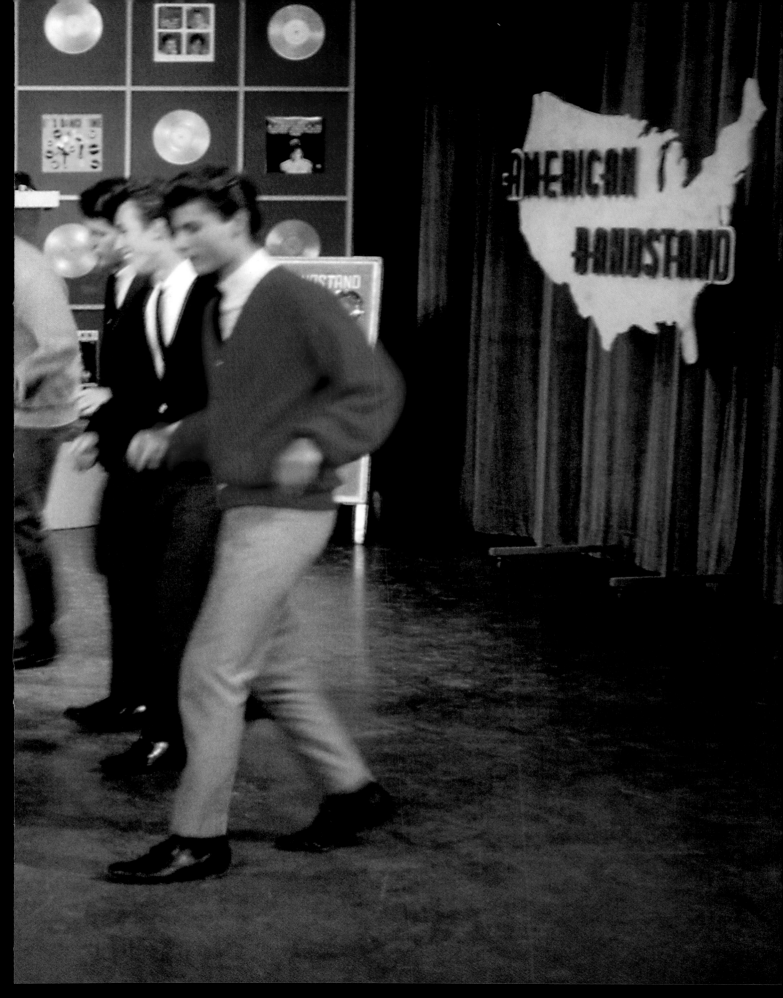

LIFE BOOKS

Managing Editor
Robert Sullivan

Director of Photography
Barbara Baker Burrows

Creative Director
Anke Stohlmann

Deputy Picture Editor
Christina Lieberman

Writer-Reporter
Amy Lennard-Goehner

Copy Editors Don Armstrong,
Barbara Gogan, Parlan McGaw

Photo Associate
Sarah Cates

Consulting Picture Editors
Mimi Murphy (Rome),
Tala Skari (Paris),
Caroline Sullivan

Editorial Director
Stephen Koepp

EDITORIAL OPERATIONS

Richard K. Prue (Director),
Brian Fellows (Manager),
Keith Aurelio, Charlotte Coco,
Tracey Eure, Kevin Hart, Mert
Kerimoglu, Rosalie Khan,
Patricia Koh, Marco Lau, Brian
Mai, Po Fung Ng, Rudi Papiri,
Robert Pizaro, Barry Pribula,
Clara Renauro, Katy Saunders,
Hia Tan, Vaune Trachtman

TIME HOME ENTERTAINMENT

President Richard Fraiman

**Vice President, Business
Development & Strategy**
Steven Sandonato

**Executive Director, Marketing
Services** Carol Pittard

**Executive Director, Retail &
Special Sales** Tom Mifsud

Executive Publishing Director
Joy Butts

**Director, Bookazine Development
& Marketing** Laura Adam

Finance Director
Glenn Buonocore

Associate Publishing Director
Megan Pearlman

Assistant General Counsel
Helen Wan

Assistant Director, Special Sales
Ilene Schreider

Book Production Manager
Suzanne Janso

Design & Prepress Manager
Anne-Michelle Gallero

Brand Manager Roshni Patel

Associate Prepress Manager
Alex Voznesenskiy

Special thanks: Christine Austin,
Katherine Barnet, Jeremy
Biloon, Stephanie Braga, Jim
Childs, Susan Chodakiewicz,
Rose Cirrincione, Lauren Hall
Clark, Jacqueline Fitzgerald,
Christine Font, Jenna Goldberg,
Hillary Hirsch, Amy Mangus,
Robert Marasco, Kimberly

Marshall, Amy Migliaccio, Nina
Mistry, Dave Rozzelle, Adriana
Tierno, Vanessa Wu

ISBN 13: 978-1-61893-041-5
ISBN 10: 1-61893-041-9
Library of Congress Control
Number: 2012938018

Vol. 12, No. 10 • April 27, 2012

"LIFE" is a registered
trademark of Time Inc.

We welcome your comments
and suggestions about LIFE
Books.
Please write to us at:
LIFE Books
Attention: Book Editors
PO Box 11016
Des Moines, IA 50336-1016

If you would like to order any
of our hardcover Collector's
Edition books, please call
us at 1-800-327-6388.
(Monday through Friday,
7:00 a.m.—8:00 p.m. or
Saturday, 7:00 a.m.—6:00 p.m.
Central Time).

Cover
Dick Clark: ABC Photo
Archives/Getty
Paul McCartney: Chronicle
Books
John Lennon: Unknown
Jimi Hendrix: Baron Wolman
Madonna: Kevin Mazur/
Wireimage/Getty
Michael Jackson: Rick Rickman
Back Cover
ABC Photo Archives/Getty
Page 1
Photograph by Paul Schutzer
Previous Spread
Photograph by Gene Trindl/
MPTV Images
This Spread
Photograph by Bruce
McBroom/MPTV Images

DICK CLARK

And the History of Rock 'n' Roll

Introduction

The Music Man

They could have crafted a movie about him: the fellow who came to town—in his case, Philadelphia—and won everyone over. They didn't have to. Dick Clark wrote the script himself.

In the film of Meredith Wilson's classic musical, Robert Preston plays (as he did on stage) Harold Hill, who is more than a bit of a huckster, a salesman supreme, but a man in touch with his own sense of self and with, deep down, a humanity that we perceive in Scene One and that we know will play out in the end. We see him as inauthentic when he's schmoozing with the townsfolk of River City, but somehow we are confident of the authenticity at his core. He'll come around, and he won't let us down. Robert Preston, playacting, was the Music Man. Dick Clark, in real life, was the Music Man.

It's so strange that he was so absolutely right for rock 'n' roll. He wasn't musically gifted, he wasn't downtrodden, he wasn't particularly rebellious, he wasn't bluesy or what might be called soulful—he wasn't any of that. He wasn't even longhaired, and it is assumed he showered every morning.

But he was just the right person at just the right time and place to shake American culture in a very similar way to the way Elvis or Brando or the Beatles would shake American culture. Yes, Dick Clark.

This book is not about his place in the world of daytime game shows or TV specials. We applaud his achievements in those realms and in no way denigrate his efforts. But what interests us, at LIFE, is Dick Clark and rock 'n' roll. Without him, Jerry Lee Lewis is a lesser figure, and how can anyone imagine two more different American celebrities than Dick Clark and Jerry Lee Lewis? Without

him, Chuck Berry is a lesser figure. Without him, kids wouldn't have known how to dance when they went to the church teenage social on Friday night. And that was a very, very important thing to know how to do.

Dick Clark was always focused on the next hour or on the day ahead, and didn't realize what he'd been responsible for until much later—during that introspective and contemplative period of life that we all arrive at, if we are so lucky. But he

ABOVE: The young man on the rise in 1959. Opposite: *Bandstand* in full swing in Philadelphia—Dick on the phone, taking votes on who or what's most popular.

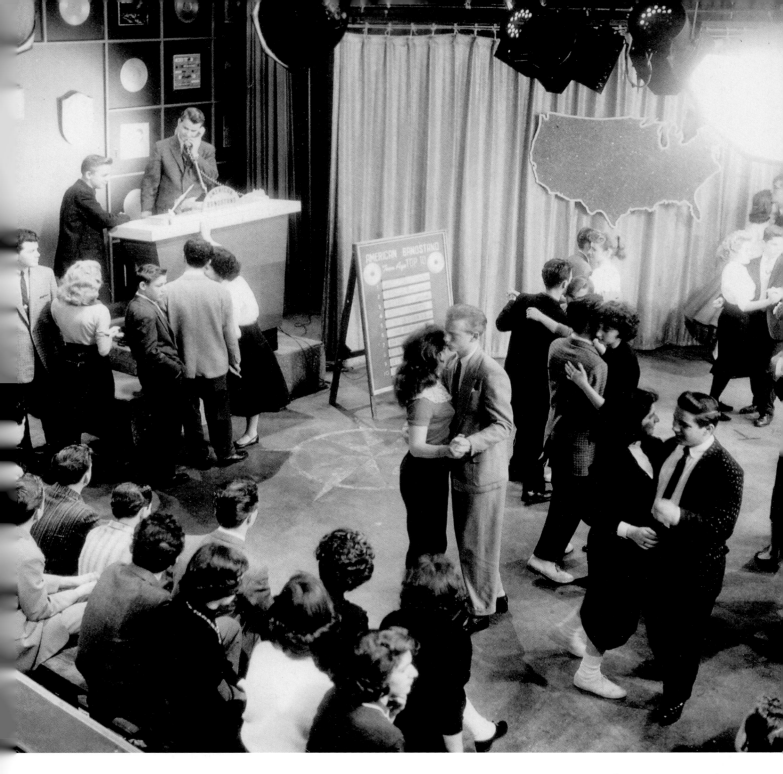

did realize it, finally, and was justly proud of it.

Lots of folks in rock 'n' roll have thrilled us. Lots of folks have, to nod to Sly, taken us higher. But lots of folks have let us down. Clark never did—he never betrayed the sense of trust he had built with both the parents and their kids.

There are lots of barricades in rock history: I'm too cool for you, I'm too tough, I'm too out there, I'm too mean, I'm too soft, I'm too sexy for my shirt. There are too few bridges. Dick Clark was the bridge at just the right time, when a horde of American kids needed the music, and their parents didn't quite know what to do. Just like back in River City.

What a solid bridge he was. Dick Clark never let us down.

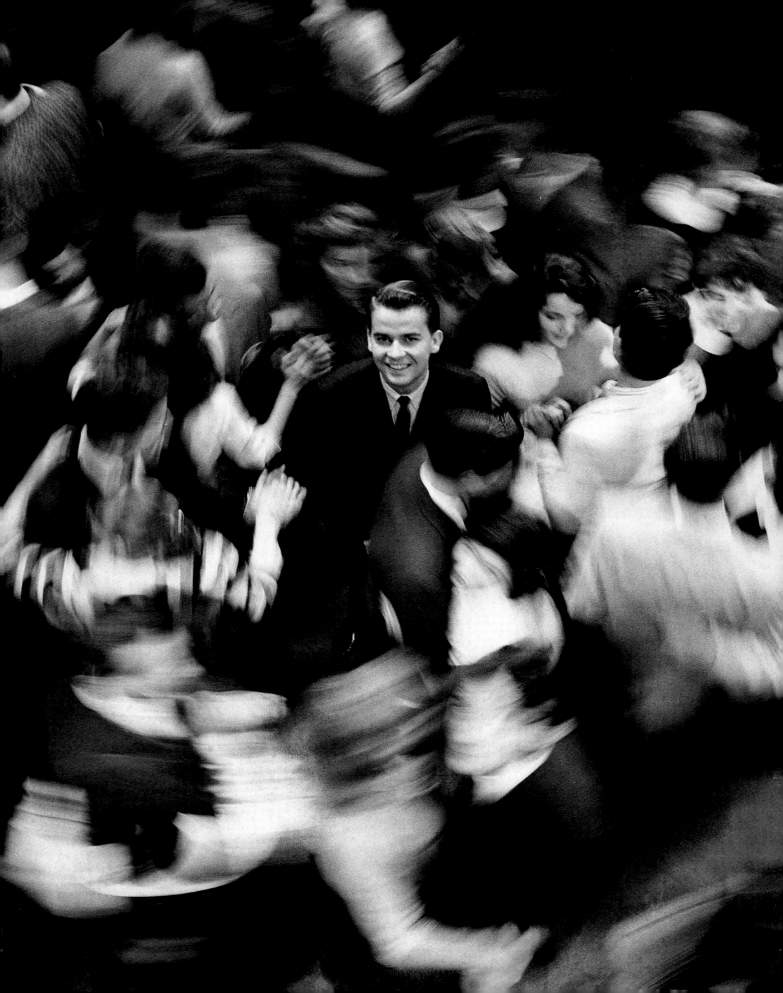

As Dick Remembered It

It has been said that the first rock 'n' roll single, Ike Turner's "Rocket 88," was cut in 1951. It has been said that the first great rock 'n' roll show took place the very next year. Dick Clark was a young man, listening in. A decade ago he sat down with the editors of LIFE, and recalled the time. These are his words.

Nineteen fifty-two. That was quite a year. Deejay and promoter Alan Freed had his Moondog Coronation Ball in Cleveland Arena on March 21. Some say that was the first rock 'n' roll stage show. When the crowd stormed the doors, it certainly became the first rock 'n' roll riot. Lloyd Price's "Lawdy Miss Clawdy" started picking up white buyers as well as black in 1952. Down in Memphis, producer Sam Phillips started his Sun label that year. Up in Philadelphia, where I was at the time, a new afternoon show began on WFIL-TV. Hosts Bob Horn and Lee Stewart called it *Bandstand,* and it was instantly popular. I was an announcer at WFIL's radio and TV stations and didn't have anything to do with *Bandstand* right away. But I could tell something was happening in 1952.

I had grown up in Mount Vernon, N.Y., and had wanted to be in radio since I was 13. Rhythm and blues wasn't widely popular yet, never mind rock 'n' roll. I was drawn to big band music vocalists. I dated a girl in high school who liked jazz. Through her, I sort of got in sideways to black music. I loved rhythm and blues.

I got a job at the campus radio station when I went to Syracuse University, then the job in Philly, just as things were about to change. Kids were embracing a new form of music and it just could not be stopped, not that people didn't try. I've got a couple of quotes here. One is from U.S. Congressman Emanuel Celler, who said at a government hearing in the mid-1950s,

"Well . . . rock and roll has its place, there's no question about it. It's given great impetus to talent, particularly among the colored people. It's a natural expression of their emotions and gyrations." Then he went on to say that in his considered opinion, however, these "animal

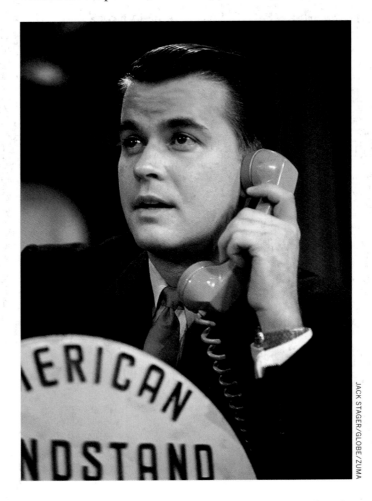

ONCE BANDSTAND HIT, Clark would be in the midst of a maelstrom. But earlier, as he testifies here, he was just a fan of rock 'n' roll.

CLEVELAND DEEJAY Alan Freed loved black rhythm and blues but changed the term to skirt racial issues in naming his radio show *Moondog's Rock 'n' Roll Party.* When he staged his Moondog Coronation Ball at 10,000-seat Cleveland Arena, more than 20,000 showed up, certifying rock as the coming craze.

gyrations" and the music itself "caters to bad taste." The songwriter Billy Rose also testified at that hearing and enthusiastically agreed with Celler that most of the new songs were "junk . . . in many cases they are obscene junk pretty much on a level with dirty comic magazines." Rose saw rock 'n' rollers as "a set of untalented twisters and twitchers whose appeal is largely to the zootsuiter and the juvenile delinquent." This was from the man who gave us the lyrics "Barney Google, with the goo-goo-googly eyes."

But as I say, there was no stopping rock 'n' roll. We could see this at WFIL. *Bandstand* was supposed to be a musical film show, but the kids got bored just watching the film clips and got up and danced. The station started bringing singers into the studio to lip-synch their hits. Suddenly, *Bandstand* was the most popular show in the city and the most exciting. I was lucky enough to become host of the show in 1956. When we took it national on ABC soon thereafter, we had a phenomenon on our hands.

Those were great years. We had Chuck Berry on the show, Fats Domino, the Everly Brothers, Bill Haley, Dion and the Belmonts. Elvis never played *American Bandstand,* but I certainly do remember the first time I saw Elvis, at the arena in Philadelphia at 46th and Market. I knew he was something bigger than life. I can remember it now . . . You were absolutely unable to hear the music for all the screaming!

I was not impressed with the Beatles at first, nor was the *Bandstand* audience. "She Loves You" had come out on the Swan label. We put it on "Rate-a-Record" and gave it a spin. The kids gave it a 73 rating . . . not too good. I thought the Beatles were

essentially a British bar band, something out of Buddy Holly. But, of course, as they evolved, they changed everything. They wrote their own songs, they painted pictures musically, they did concept albums . . . They took '50s rock 'n' roll and added strings, new percussion, jazz, folk. They expanded all boundaries.

I wasn't a part of the psychedelic drug period . . . I smoked and drank, but I sure didn't need another vice! Nevertheless, on *Bandstand* we debuted Jefferson Airplane, the Mamas and the Papas, the Doors. I remember Jim Morrison really didn't want to be there. His manager brought the Doors on *American Bandstand* as a favor. Some of the music I loved, some I didn't.

A short time ago I bumped into Grace Slick in a supermarket line in Malibu, and I asked her about those days. I asked her if she remembered the Airplane playing *Bandstand.* "I don't remember anything about the '60s," she laughed.

Rock just kept lasting . . . It has now stayed longer at the top than any other form of popular music. When I speak of rock, I am referring to its lineage and to its continuing influence. Little Richard inspired Elvis Presley, who in turn influenced Michael Jackson and Prince. Those two certainly have had a huge impact on today's music. The boy bands and Britney Spears owe everything to rock 'n' roll. Entertainers like Garth Brooks were influenced as much by Kiss and Aerosmith as by George Strait.

Through this exciting evolution, there have been many chroniclers of rock 'n' roll. One who has been there since the beginning is LIFE. I've always felt that music is visual. I've said for years that "music is the soundtrack of your life." Listening to it spurs memories . . . That's when you fell in love; that's when you graduated from school; that's when you got that job; and that's when you lost that job. The pictures, for me, work the same way. Let your eyes float over them and you hear the music playing.

PETER HASTINGS

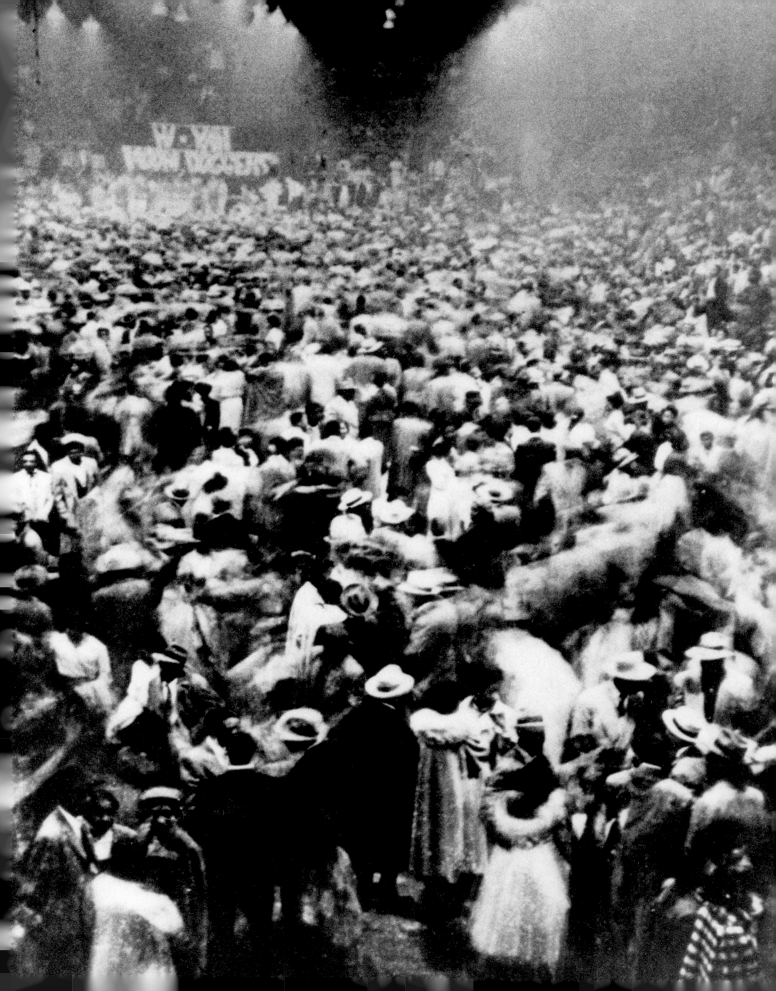

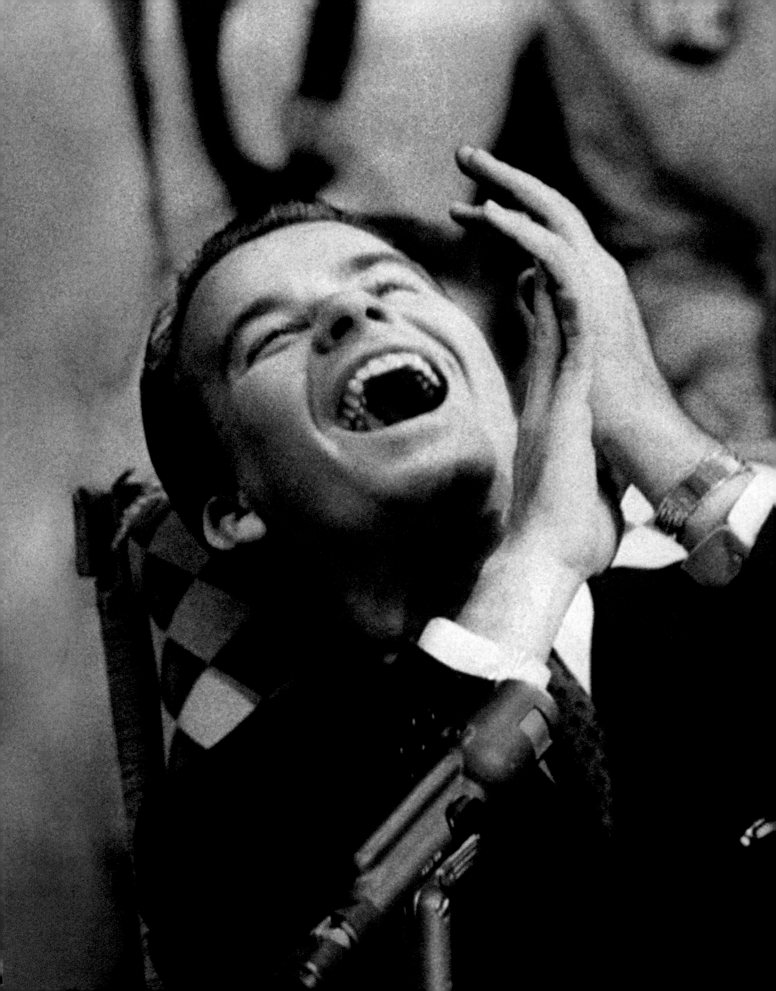

PAUL SCHUTZER

"For Now, Dick Clark . . . So Long"

America's teenagers—and teenagers at heart—heard the phrase every afternoon. Years later, we heard it annually, sometime after midnight at the close of the New Year's Eve show. Now, we have lost a friend, one who made us smile, and played for us the soundtrack of our lives.

As we all know, having read the sheaf of deserved celebrations of Dick Clark in the last several days: This man can be appreciated in many, many ways for many, many things. He was a member of four or five different halls of fame, for goodness' sake. We can remember him as a tremendously successful entrepreneur, a television pioneer, a cultural touchstone.

We choose to celebrate him, in these pages, for the starring role he played in the history of rock 'n' roll.

He never indulged in a seven-minute drum solo, he never set fire to his guitar, he never duck-walked. He never sang lead or even backup, he never wore his hair longer than the Nice Boy Next Door. He sported a necktie and a blazer from dawn to dusk: The pressed clothing seemed as permanently in place as the broad, winning, earnest smile.

THE YEAR IS 1958 and Dick Clark is in Philadelphia—and on top of the world. His show, *American Bandstand*, is as hot as hot can be.

But as Mr. Clark's reminiscence on the previous pages indicates, he was a rock 'n' roll child. He was there to witness the beginning of it all. He was one of the young people with an ear cocked when America began to turn up the volume.

Shortly thereafter, he became a part of it. In fact, a very big part of it. He would, before the 1950s were out, grow to be vastly influential. Young folks who had formerly visited *Romper Room* or *The Mickey Mouse Club* on a daily basis now tuned in every afternoon to *American Bandstand.* Clark could (and would) be a kingmaker. He can be credited for, or blamed for, such as Frankie Avalon, Bobby Rydell and Fabian—the Philly teen dreams, just kids from the neighborhood, who became known as the "Boys of *Bandstand.*" Clark was quick to spot a trend and never slow to react; it's why his career was so peripatetic, involving this game show and that bloopers show, this movie and that one, this beauty pageant and that one, not to mention ownership of New Year's Eve (Guy Lombardo could have sued!). Dick Clark was constitutionally unable to not follow through on a hunch, and in the late 1950s and early '60s, many of his hunches redrew the cultural landscape for America's large generation of Baby Boomers.

In 1964, for instance, he agreed to add a hitless Motown group named the Supremes to his Caravan stage tour, billing them at the bottom of the 17 featured acts. So, sure: It can be said that Clark didn't appreciate just how fine the Supremes were. But as the Caravan rolled on, "Where Did Our Love Go" began getting more and more airplay. Clark ordered the early tour posters scrapped, and the Supremes started to climb toward the headliners even as their song climbed the charts. "Where Did Our Love Go"

BANDSTAND IS THE PLACE to be for the fans in Philadelphia, and these idols of Philadelphia: Frankie Avalon, Connie Francis (actually, Newark!), Dick Clark and Fabian.

GLOBE/ZUMA

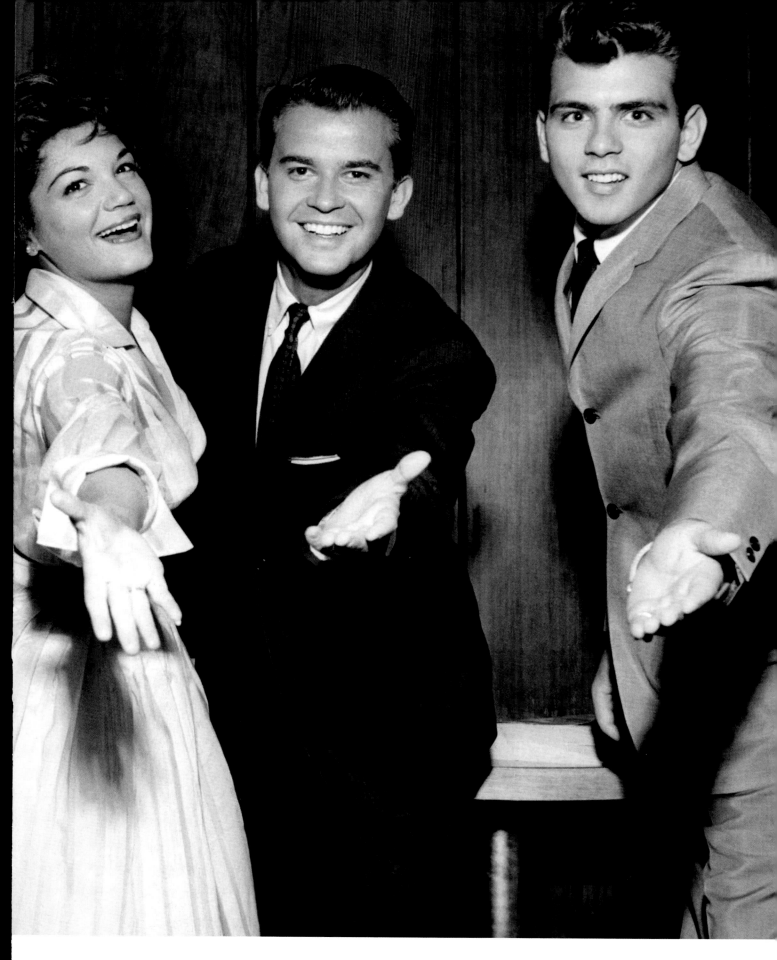

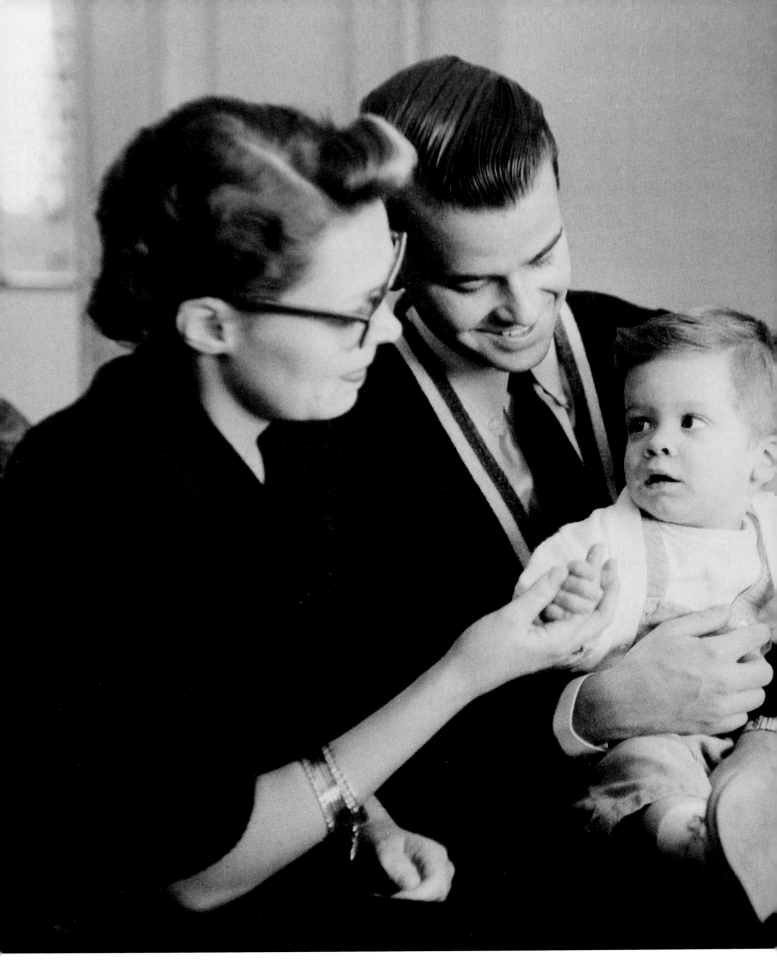

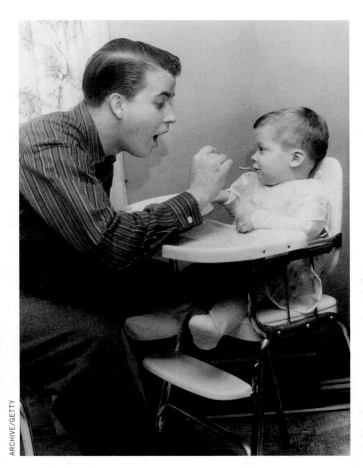

eventually became No. 1, and the Caravan had big stars on its hands—stars it had helped to boost, especially among Dick Clark's largely white audience, because of the boss's savvy and lightning fast reflexes. As the Caravan closed down, Clark pocketed his profits and was on to the next thing.

He was not only hardworking and keen-eyed, he really was happy-go-lucky and in tune with his country. "My greatest asset in life," he once said, "was I never lost touch with hot dogs, hamburgers, going to the fair and hanging out at the mall." President Obama was not wrong when he said, upon hearing of Clark's death in Santa Monica of a heart attack at age 82 on April 18, "With *American Bandstand* he introduced decades' worth of viewers to the music of our times . . . For 40 years, we welcomed him into

LIFE WITH FATHER was good in the late 1950s when Dick, his wife, Barbara, and their son, Richard, were the very model of the modern American suburbanites.

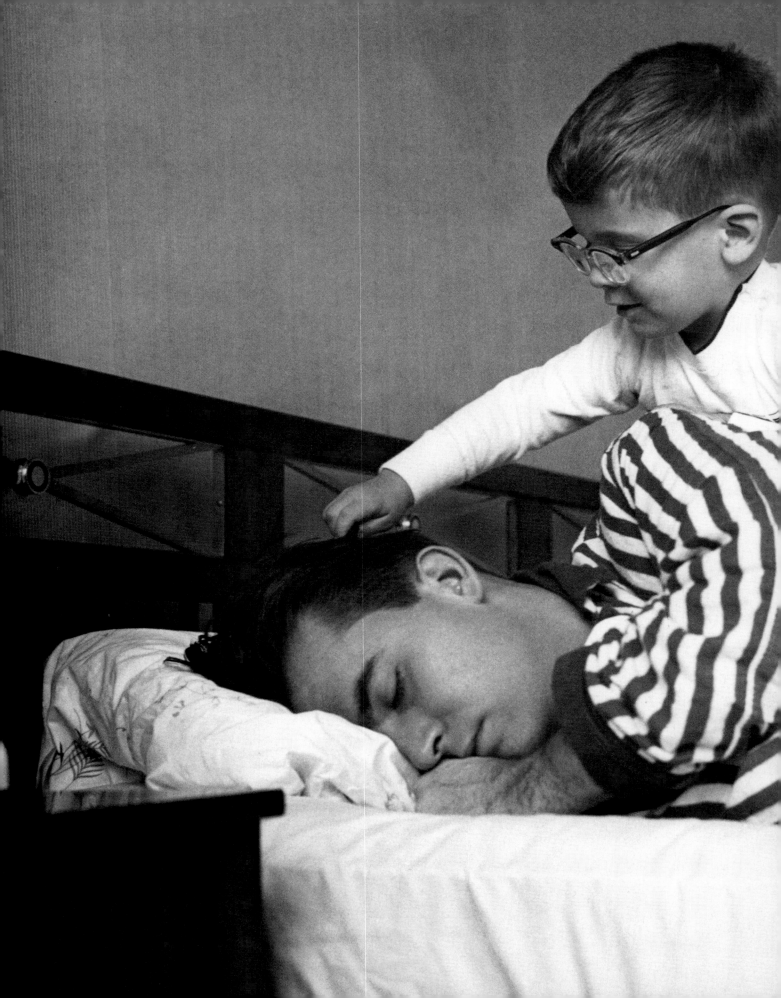

EDGAR S. BRINKER/ARCHIVE/GETTY

our homes to ring in the new year. But more important than his groundbreaking achievements was the way he made us feel—as young and vibrant and optimistic as he was."

What an incalculable contribution.

It's what rock 'n' roll was made to do.

Richard Wagstaff Clark was born on November 30, 1929, in Bronxville, New York, and moved with his family a few years thereafter to the nearby suburb of Mount Vernon. His father was a sales manager for a New York City cosmetics firm, and the Clarks did not suffer unduly during the Depression. There was an older brother, Brad, to whom Dickie was devoted— but the boys were quite different. Brad was a well-mannered, handsome sports star at A.B. Davis High in Mount Vernon, while his kid brother was frenetic, and considered himself "peculiar looking and generally odd." Brad graduated from high school in 1943 and became a fighter pilot during the war. Dick was barely a teenager, and recalled later in his memoir, *Rock, Roll & Remember,* "It was like he was deliberately deserting me . . . I sat on the bed in the room we shared and I sulked." The emotional loss became so much worse just after Christmas of 1944 when news arrived that Brad had been killed during the Battle of the Bulge.

Dick Clark was of course bereft, and for a time adrift. He seemed to want to become Brad, but failed at high school sports—attempts at football, swimming, track—where his brother had starred. Alone in his room, he found some solace in, yes, the radio: "the disembodied fantasy world that came out of the speaker." Not long thereafter he

WITH EVERYTHING he was up to, Dick might well have been sleeping in. Then again, he played up the "married the high school sweetheart and is a homebody" angle very well, and probably knew what was going on when the shutter clicked.

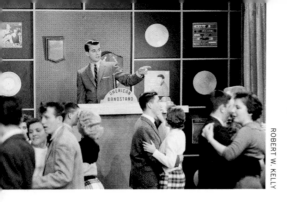

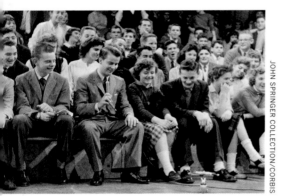

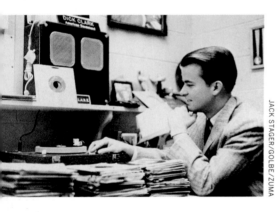

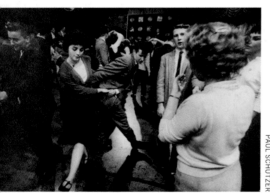

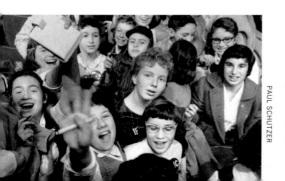

attended with his parents a broadcast of radio's *Jimmy Durante–Garry Moore Show,* and he later remembered in his autobiography that he told his mother, "That's what I want to do."

If a high school kid can't just make himself into a radio star overnight, he can nurture talents that might, one day, be put to good use. Dickie joined the drama club and became, by accounts, quite an accomplished young actor. He also must have been developing his seemingly instinctive entrepreneurial gifts, for his classmates voted him "The Man Most Likely to Sell the Brooklyn Bridge." If they had bothered to build a dossier, they could have listed: Dick's gossip sheet, which sold for two cents per copy; Dick's restaurant, using the stores of his family's kitchen; Dick's shoeshine stand, where a single shoe polished cost three cents and a pair was a bargain at five. Clark never would sell the Brooklyn Bridge, but down the years he sold just about everything else.

Richard and Julia Clark, Dick's parents, were natives of upstate New York, and when Julia's brother asked Richard if he might want to be the promotional manager of the Utica radio station that the brother owned, a fateful shift was made. The Clarks moved north to quieter precincts. Dick Clark would attend nearby Syracuse University, and, thanks to his connections with his dad and uncle, would intern at WRUN, sometimes even getting to read the weather reports and station breaks. He installed an antenna at home so his mother could hear him better.

He was good, he was a natural. When TV gigs became part of the assignment, he was handsome and carefree in front of the camera, and had a fine voice. But of course he was in

LIFE AT BANDSTAND really was fun, as the pictures on these pages indicate. As the photo on the following pages implies, there was also a backstage side—and Clark, a true entrepreneur, was, if anything, more comfortable with accountants and actuaries than he was with his "fellow teens."

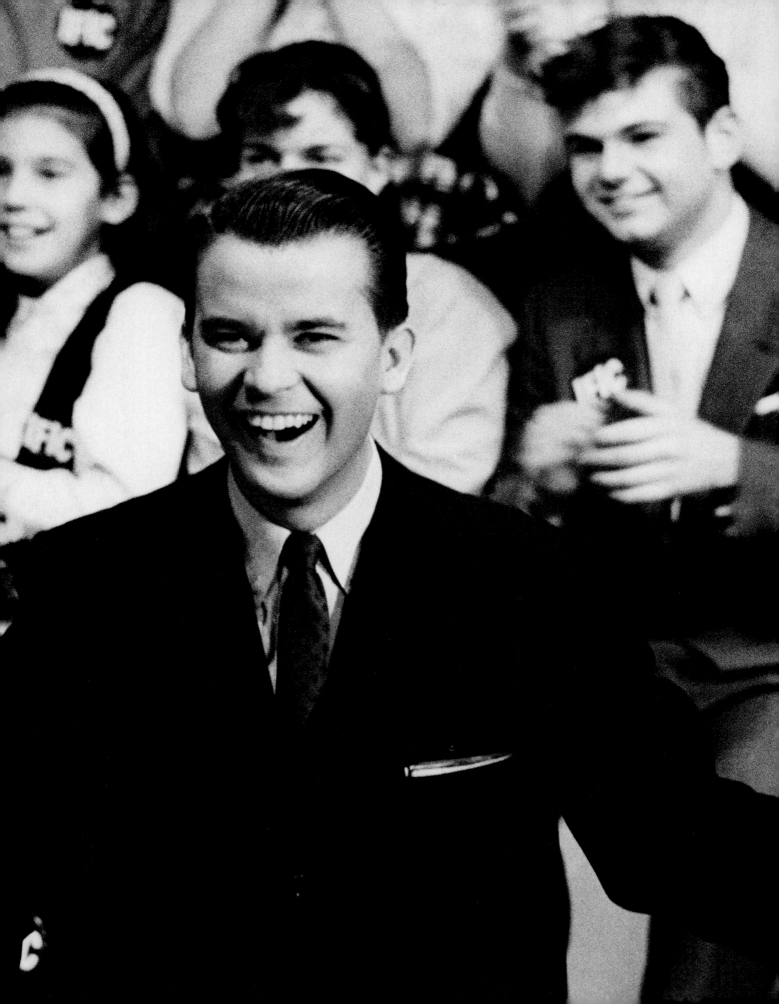

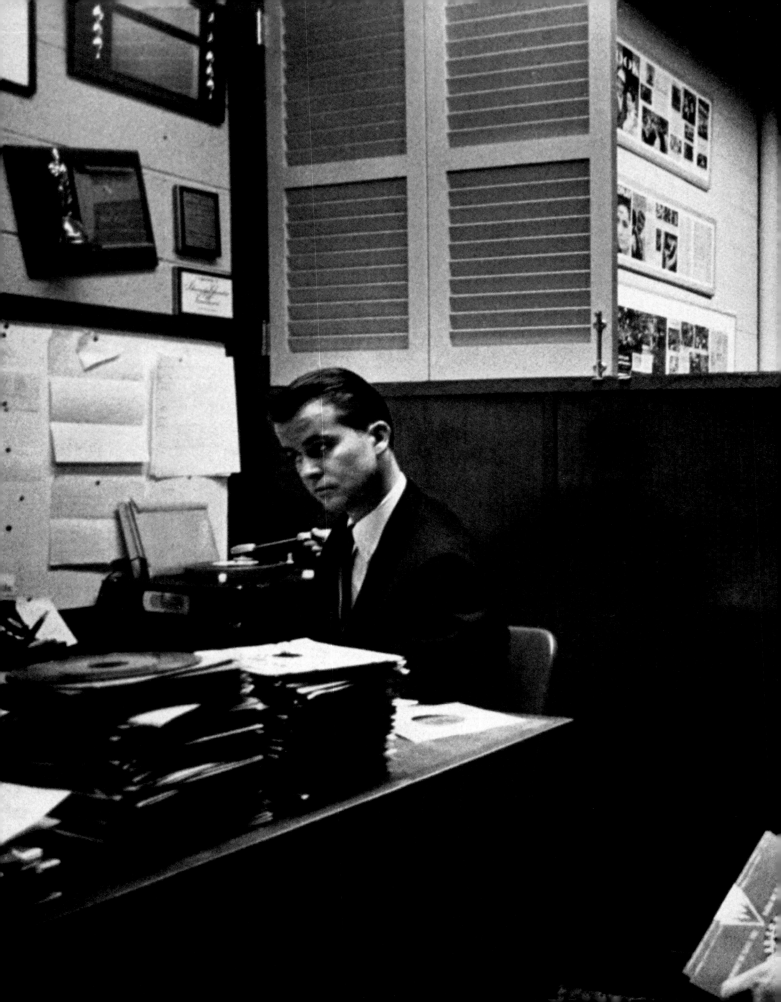

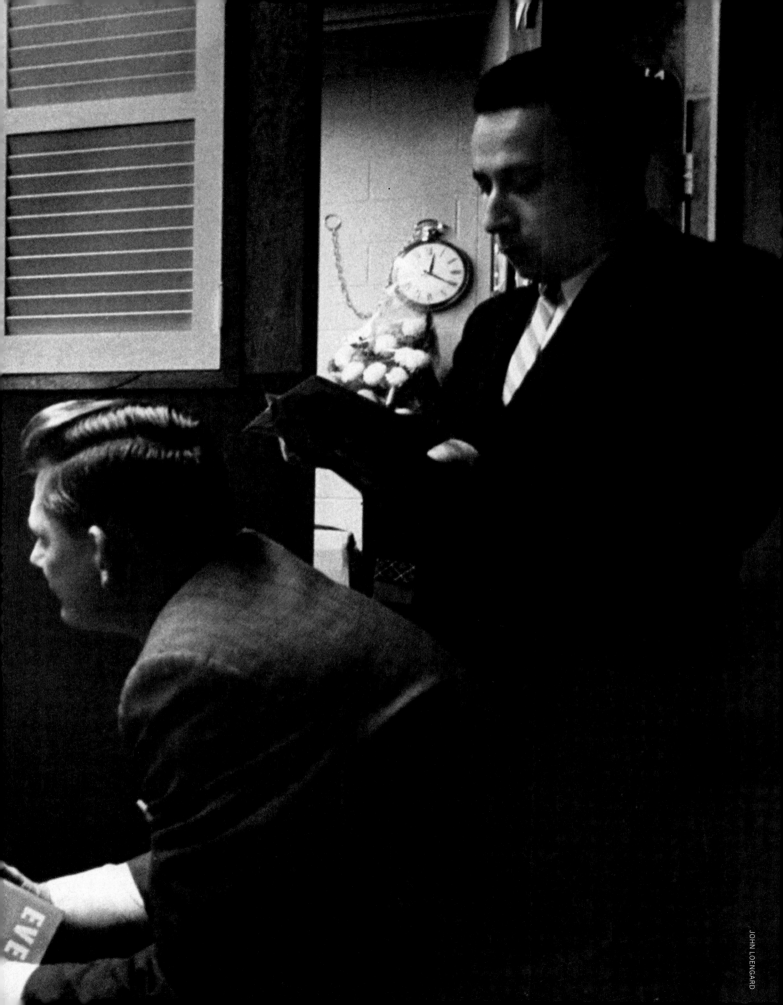

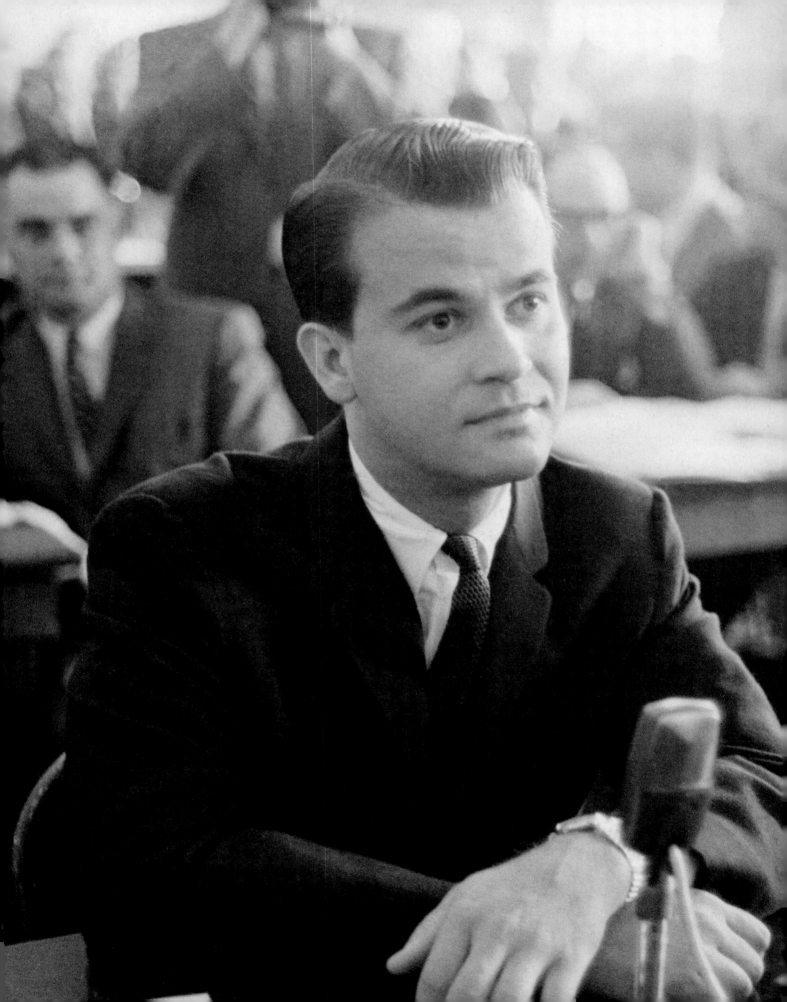

Utica. He worked at a country station in Syracuse for a time—he really didn't care what kind of music he was spinning—and debuted on television in that small city as a host on *Cactus Dick and the Santa Fe Riders.* It's called working your way up.

Next stop: the big time.

Philadelphia.

Today, if a show's going to hit it big it's going to come out of L.A., most likely, or New York. Back then, when TV was truly still a toddler and the ideas of "syndication" and even "networks" were still but babies, you might catch lightning in a bottle in any big-enough city. There are endless permutations and combinations involved in how Dick Clark came to debut on what would become *American Bandstand,* but the condensed, linear version is more easily understood and just as much fun as any of them: Clark was a young, soon-to-be college grad who felt that he had finally found his calling; he sensed he was in a cultural backwater in upstate New York and wanted to break out; his father and uncle's radio station was affiliated with ABC; his dad therefore had connections in Philly; it seemed there was a radio job in Philly; this looked like Shangri La or the yellow brick road to Oz to young Dick; he landed in the City of Brotherly Love, where there was no love lost between him and the touchy Bob Horn, a 37-year-old radio veteran whose popular radio program *Bandstand* on WFIL was sidling over to TV; Horn wasn't all that handsome and, so, was not necessarily TV-ready; Horn got busted for drunk driving and fired; Clark—everything Horn was not—stepped in as a replacement, inherited Horn's intelligent and talented producer, Tony Mammarella, and was

NOT A MICROPHONE of his choosing. In April 1960, Clark appears before House of Representatives investigators looking into the payola scandal, in which music spinners were paid to play certain songs. He will not be indicted, but his image will be sullied.

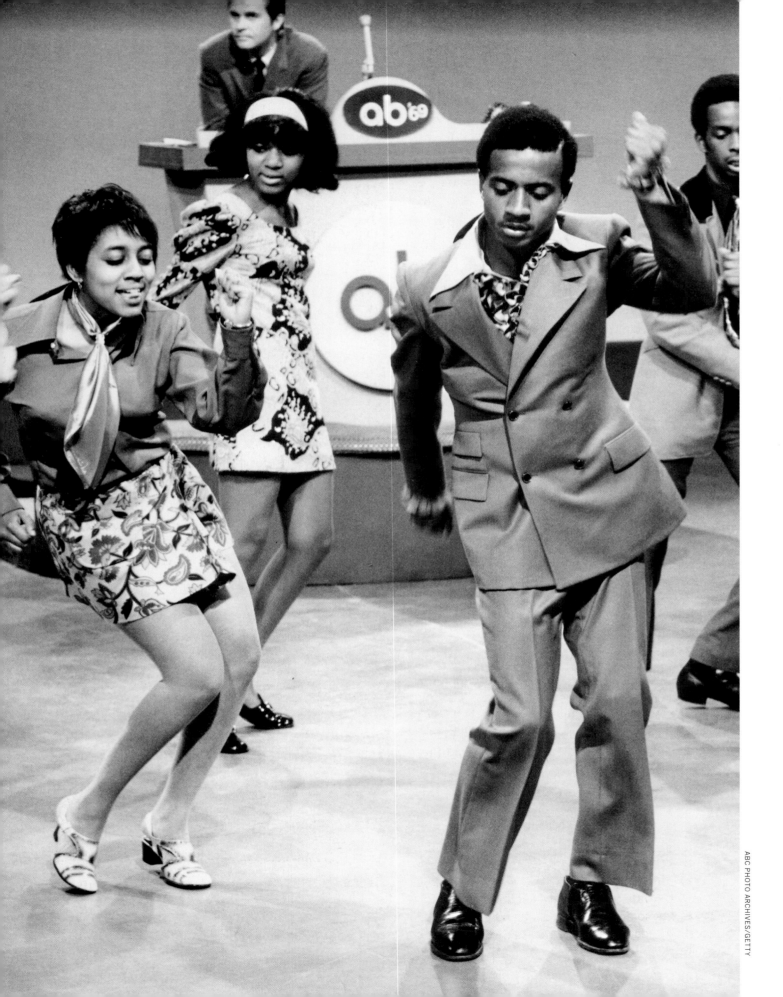

off to the races. And speaking of races: Clark and Mammarella decided relatively early on, once it became clear that *Bandstand*—renamed *American Bandstand* on ABC—would reach the whole nation, to include African American performers on their show, and to integrate the dance floor as well. These were the people making the hits, this was what the kids wanted, this was the way the kids felt. Clark later said that the first time in his life he had sweaty palms was when he interviewed a black teenager on the *Bandstand* dance floor during a rate-the-record segment. Clark, who was always frank about his business savvy—he enjoyed meetings with numbers crunchers as much as he enjoyed spinning the latest from the Temptations for the first time—might have had an eye on Southern affiliates that might drop the show, or he might have just been nervous. But all the credit goes to Clark and Mammarella. It has been said that *Bandstand* presented to many Baby Boomers on a daily basis the first look at what a racially integrated, hopeful, energetic United States of America could be.

But first, it had to become a hit. It accomplished that, and quickly enough. Since the show has often been called a cultural scene-shifter, it is interesting to revisit just how big a hit *American Bandstand* actually was. It was a Big hit.

Big Big Big Big Big.

As mentioned, Bob Horn had come a cropper with the DWI patrol. On July 9, 1956, Dick Clark took over the scene—such as it was—on WFIL-TV's modest-beyond-modest Studio B. The kids of Philadelphia knew where this was, on Market Street, and they were showing up, the boys

THOUGH CLARK could not derail *Soul Train,* he did more—and earlier—to show young America what an integrated society looked like (opposite; this page, top, with Little Richard; center, doing the Twist in 1960 with Conway Twitty and Chubby Checker). At right, he waxes rhapsodic about the Beatles, but they are not guests this day—and in fact represent *Bandstand's* bête noire.

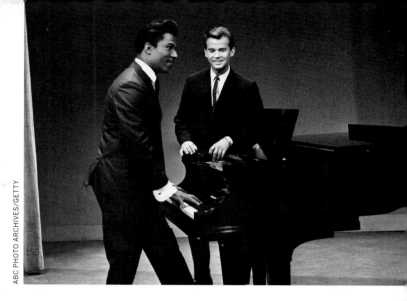

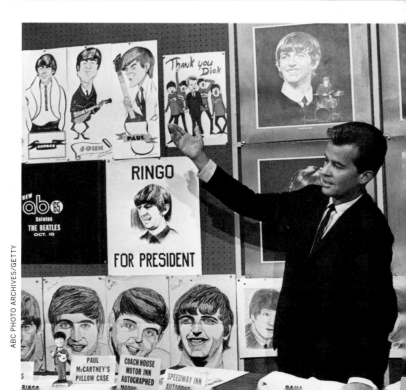

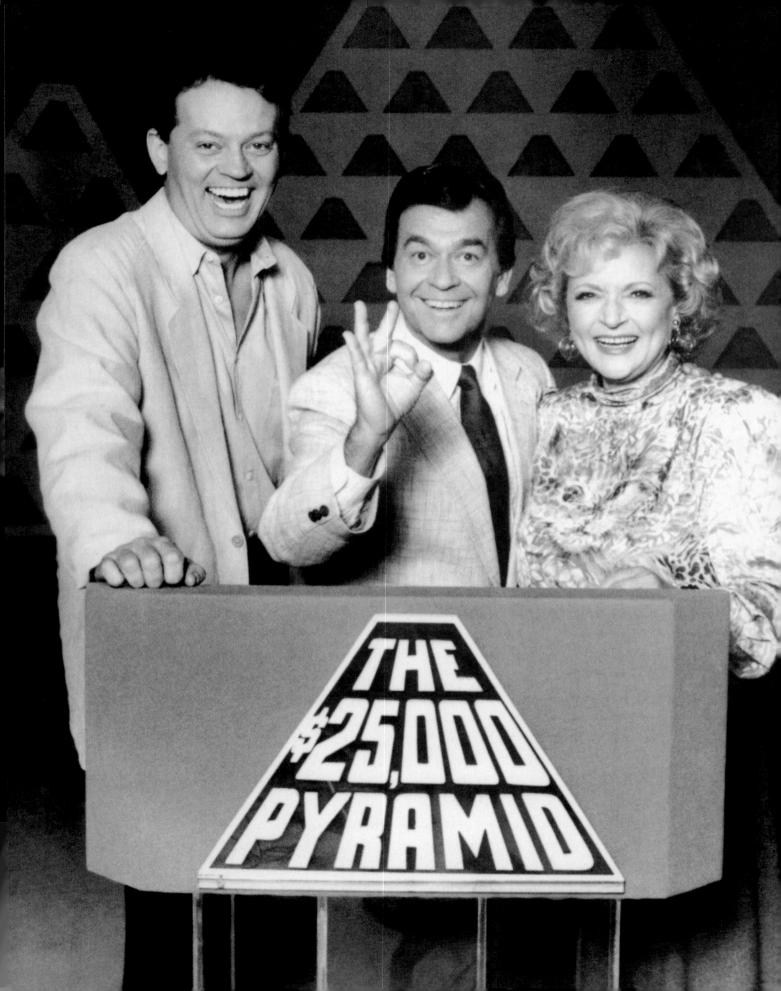

in neckties, the girls in dresses, and no gum-chewing (those were the rules). Even before the show found its way, it was clear Dick Clark was perfect for this particular deal. He was smart, and though he knew little about rock 'n' roll, he was a quick learner, and so he was the kids' big brother, telling them about the next big thing. He was clean-cut, which made him the parents' avenue—or perhaps alternative way in—to this thing that was rock 'n' roll. As Geoff Boucher of the *Los Angeles Times* put it in his recent obituary of Clark: "Nicknamed 'America's oldest teenager' for his fresh-scrubbed look, Clark and *American Bandstand* not only gave young fans what they wanted, it gave their parents a measure of assurance that this new music craze was not as scruffy or as scary as they feared. Buttoned-down and always upbeat, polite and polished, Clark came across more like an articulate graduate student than a carnival barker." True, yet Clark and Mammarella realized how attractive carnivals are to kids, and *American Bandstand* came to feature games, teens who couldn't contain themselves, and viewer voting on such things as the best songs. Ryan Seacrest is the first to admit that *American Idol* is nothing new under the sun and that Dick Clark was, in fact, his American idol. Clark, for his part, said that he learned all his most famous lessons from Arthur Godfrey. What he most admired was that Godfrey seemed to be speaking to each individual out there, not to some amorphous and undefined audience. Godfrey seemed genuine and involved, and so would Dick Clark.

Crucially, Clark and Mammarella understood the music, the trends and what might be next. In the late 1950s and early '60s they seemed to have a wizard's talent for predicting what was coming, but this was at least in part because

IN 1988, Clark's popular game show *The $10,000 Pyramid* has obviously grown in value. He is seen here with David Graf and the always popular Betty White.

they were involved in the seismic shift. Once *American Bandstand* was aired nationally by ABC and took off, Clark could create stars. Witness, as has been acknowledged, what he did for the Philadelphians he passed on the way to work: Fabian, Frankie Avalon, Bobby Rydell. But Clark always felt his show should reflect what was out there or about to be out there, and he wasn't as concerned with making stars as featuring them. An early record he played, in 1957, was the controversial "Whole Lotta Shakin' Goin' On" by Jerry Lee Lewis, and Clark quickly learned that his teenage guests couldn't just sit and listen; they wanted to get up and move. *American Bandstand* introduced to a national TV audience such performers as Chuck Berry, Bill Haley and His Comets, James Brown, Buddy Holly, the Everly Brothers.

Pause for just a moment of mathematics. By late 1958, *American Bandstand* was being watched every afternoon by 40 million viewers. The population that year in the United States was 174,054,000, meaning that one in every four or five Americans was watching *Bandstand* on a daily basis. Considering when it aired, we can presume that many adults were at work and not watching. Today, there are more than 312 million Americans. The most-watched TV show each year is the football Super Bowl, and in 2012, in a record-setting showing, it drew 111.3 million fans. So one in three citizens watched the Super Bowl, kids and adults among them. *American Idol* and *CSI* and all the others: Their viewership ratios can't come close to those of *American Bandstand* in its heyday, what with all the cable channels and the diversification of our national culture. The point: *American Bandstand* was, for our nation's youth, a daily Super Bowl, the very definition of must-see TV. If you weren't at baseball or softball practice or in detention, you were with Dick Clark.

American Bandstand lasted, we have been told in the obituaries of Dick Clark (and of his show), for

an amazing four decades. But really it lasted from 1957 to 1963, then became a weekly show, then Dick went off to other things, and then and then . . .

What killed off *Bandstand*?

In two words: the Beatles.

Clark, who was well into Elvis, told LIFE that he wasn't impressed with the Beatles at the outset, and that "She Loves You" didn't rate well with the *Bandstand* audience. But there was another problem: They not only weren't from Philadelphia, they weren't from America. They weren't an easy get. And by 1964, things had changed. The enormous success of *American Bandstand* had caused others to take notice. The Sunday night *Ed Sullivan Show* would be the introductory venue for many British Invasion acts, most famously the Beatles, and now there were new programs—*Shindig, Hullabaloo*—angling for acts. *Bandstand* would still play a part, helping boost the careers of such as the Mamas and the Papas and even Madonna, but MTV was on the far horizon, and the show's place as One of the Most Important Shapers of American Culture Ever was over.

Dick Clark was in no way done. He had emerged from the payola scandal of the late 1950s—in which disc jockeys were paid to play certain songs—somewhat unscathed (though chastened); he had ridden the crest of the *Bandstand* wave; he had become a celebrity (image: a handsome guy who had married his high school sweetheart and was having children; there would ultimately be three wives—two divorces—and three kids); he had branched out into production and even appeared in movies; he was thinking of new shows. At one point he tried to answer Don Cornelius's *Soul Train* success with what can be called an African American version of *Bandstand,* but that didn't work. More successful was a new daytime show, *Where the Action Is,* which was really quite

terrific, from its Freddy "Boom Boom" Cannon theme song to its regular appearances by the wonderful Paul Revere & the Raiders. Despite the Raiders' all-American roots, the show hoped to make hay with the British Invasion, and ran film clips of such acts as the Who and the Spencer Davis Group performing on the streets of London. Again, Clark was pioneering: Many three-minute snippets from *Where the Action Is* can be seen as forerunners of the music videos soon to dominate teen culture. But, in his rock 'n' roll life, Dick Clark would never have another *Bandstand*.

Nor would anyone else.

As said, Dick Clark had other lives. In this particular book, which is about the music and Clark's place in it, we are not concerned with *The $10,000 Pyramid* (which grew to become a *$100,000 Pyramid*), or the hostings of the Miss USA and Miss Universe pageants or even—sorry—the many *New Year's Rockin' Eves.* We surely are not concerned with *TV's Bloopers & Practical Jokes.*

We do note, and are happy to, that through the years Clark had influential associations with fellow giants like Ed McMahon, Johnny Carson and today's Jon Stewart. He won six Emmy Awards, and additionally, a Daytime Emmy Lifetime Achievement Award. He was, as we mentioned at the beginning, made a member of all of these various halls of fame, including radio's in 1990, broadcasting's in 1992 and rock 'n' roll's in 1993. Meantime, he made a veritable ton of money. He was a very successful and routinely happy man.

Meantime as well, he—perhaps as much as Elvis or Chuck or John or Paul or Mick or Madonna or Adele—helped make us who we are.

NOW, THERE WILL BE NO MORE New Year's Eves with Dick Clark. Some things seem unfathomable, and that is one.

ABC PHOTO ARCHIVES/GETTY

Eras

**B.R.
Before Rock**

In the primordial ooze of pop music, blues, country and jazz were aswim.

Rock 'n' roll, which through the years would splinter in many directions—folk rock, country rock, soul, fusion—had from its conception the DNA of all American music. Country music pioneers the Carter Family (below) were forebears of Bob Dylan, while bluesman Robert Johnson and jazz queen Bessie Smith were progenitors of R&B.

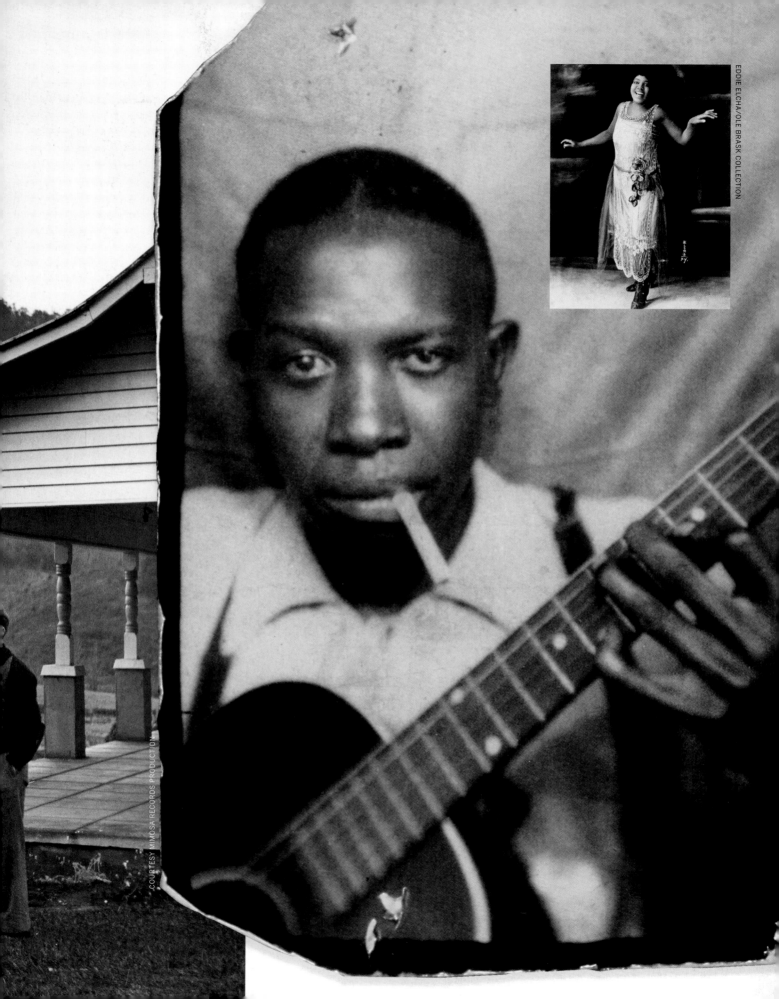

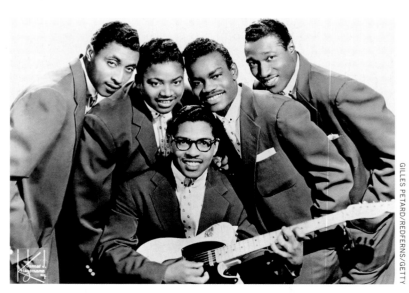

FOR BOYS who saw her on *The Mickey Mouse Club,* Annette Funicello was dreamy—plus she had hit records. Like Frankie Avalon and Bobby Rydell, Fabian was a Philadelphian made a star by Dick Clark. The Moonglows were one of the great vocal groups.

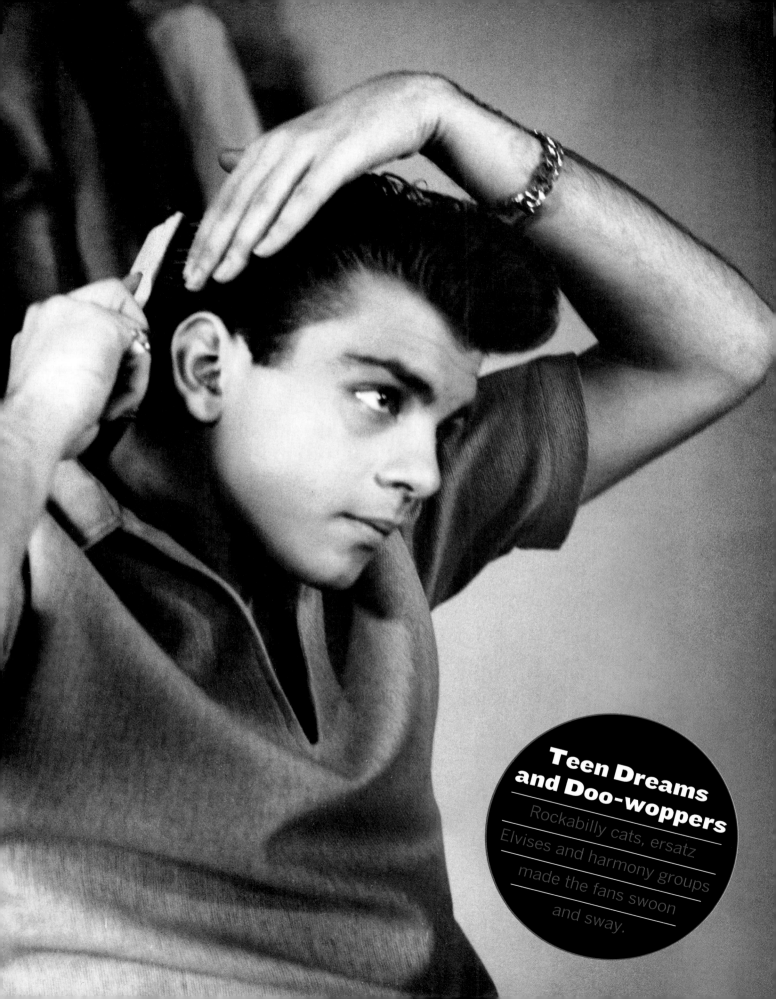

Teen Dreams and Doo-woppers

Rockabilly cats, ersatz Elvises and harmony groups made the fans swoon and sway.

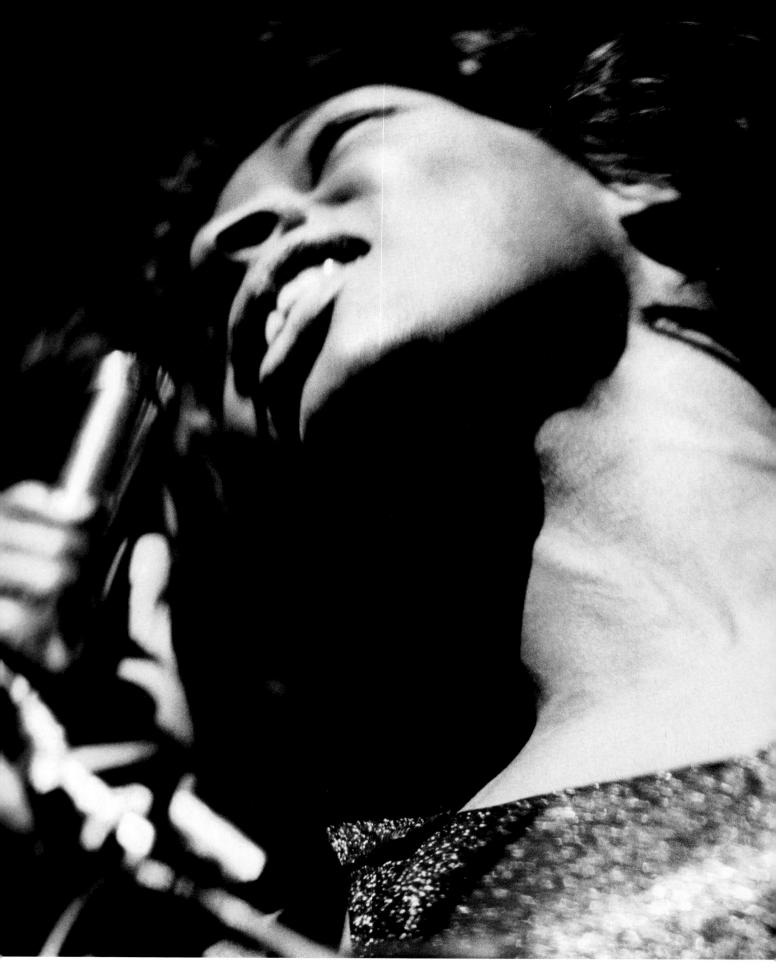

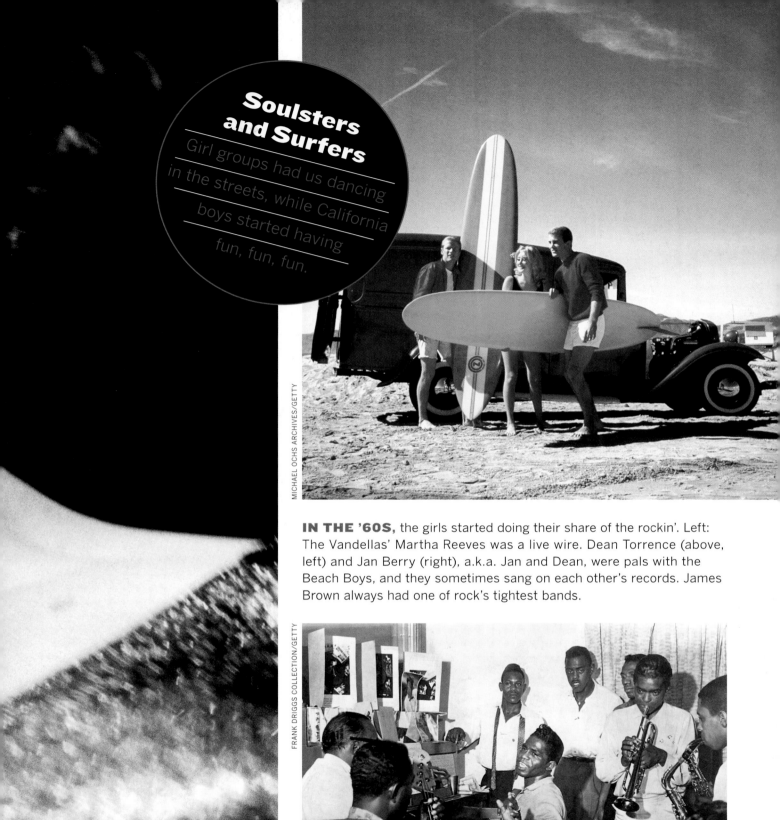

Soulsters and Surfers

Girl groups had us dancing in the streets, while California boys started having fun, fun, fun.

MICHAEL OCHS ARCHIVES/GETTY

FRANK DRIGGS COLLECTION/GETTY

JOHN LOENGARD

IN THE '60S, the girls started doing their share of the rockin'. Left: The Vandellas' Martha Reeves was a live wire. Dean Torrence (above, left) and Jan Berry (right), a.k.a. Jan and Dean, were pals with the Beach Boys, and they sometimes sang on each other's records. James Brown always had one of rock's tightest bands.

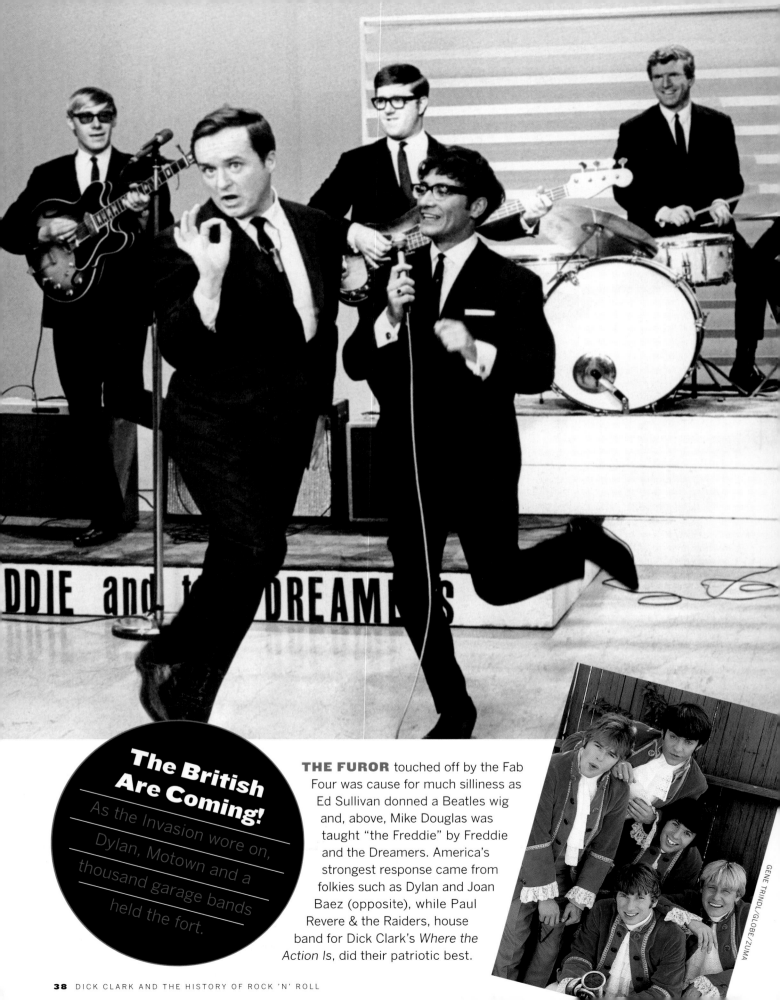

The British Are Coming!

As the Invasion wore on, Dylan, Motown and a thousand garage bands held the fort.

THE FUROR touched off by the Fab Four was cause for much silliness as Ed Sullivan donned a Beatles wig and, above, Mike Douglas was taught "the Freddie" by Freddie and the Dreamers. America's strongest response came from folkies such as Dylan and Joan Baez (opposite), while Paul Revere & the Raiders, house band for Dick Clark's *Where the Action Is*, did their patriotic best.

GENE TRINDL/GLOBE/ZUMA

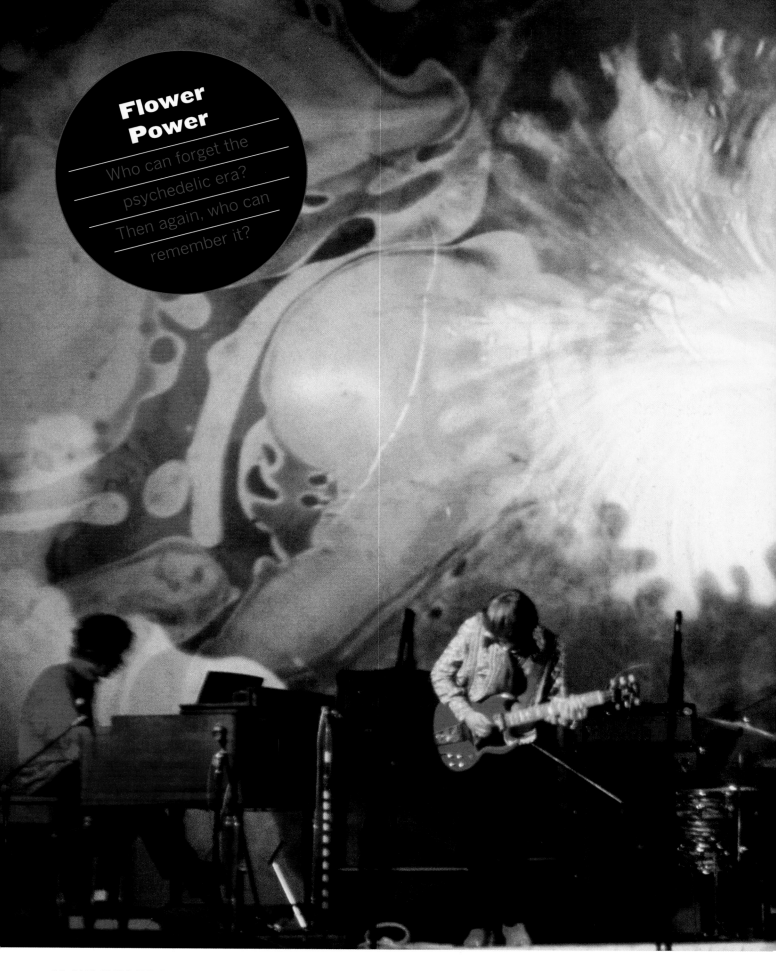

Flower Power

Who can forget the
psychedelic era?
Then again, who can
remember it?

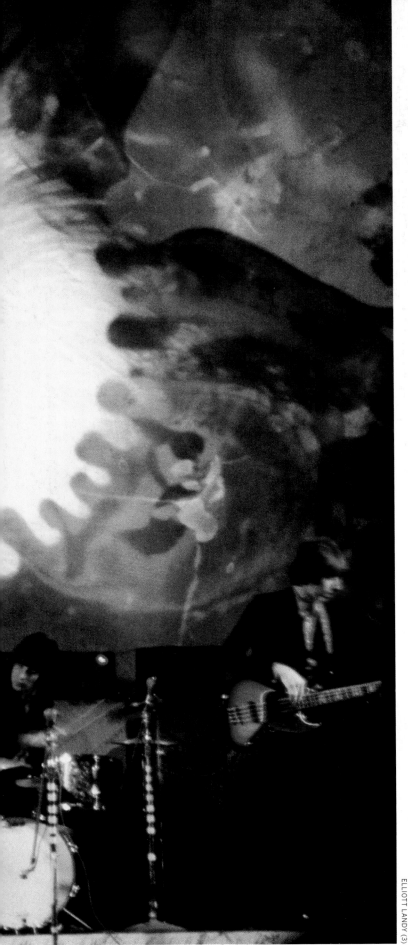

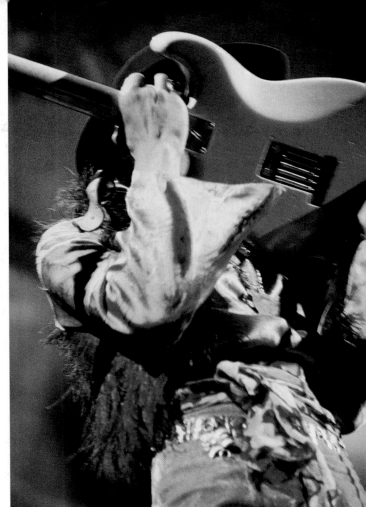

THESE PHOTOS, taken in the late '60s in New York City, feature the kaleidoscopic light shows that were de rigueur for many concerts at the time. Left: In 1968, the smart British band Procol Harum; above, some dazzling guitar work by Jimi Hendrix; below, Janis Joplin, soulful as ever. As Clark once said, and as quoted earlier in our pages, "I wasn't part of the psychedelic drug period . . . I sure didn't need another vice."

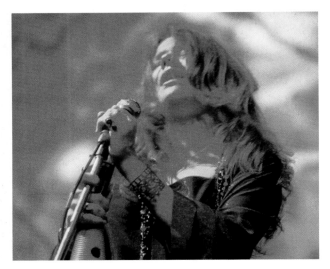

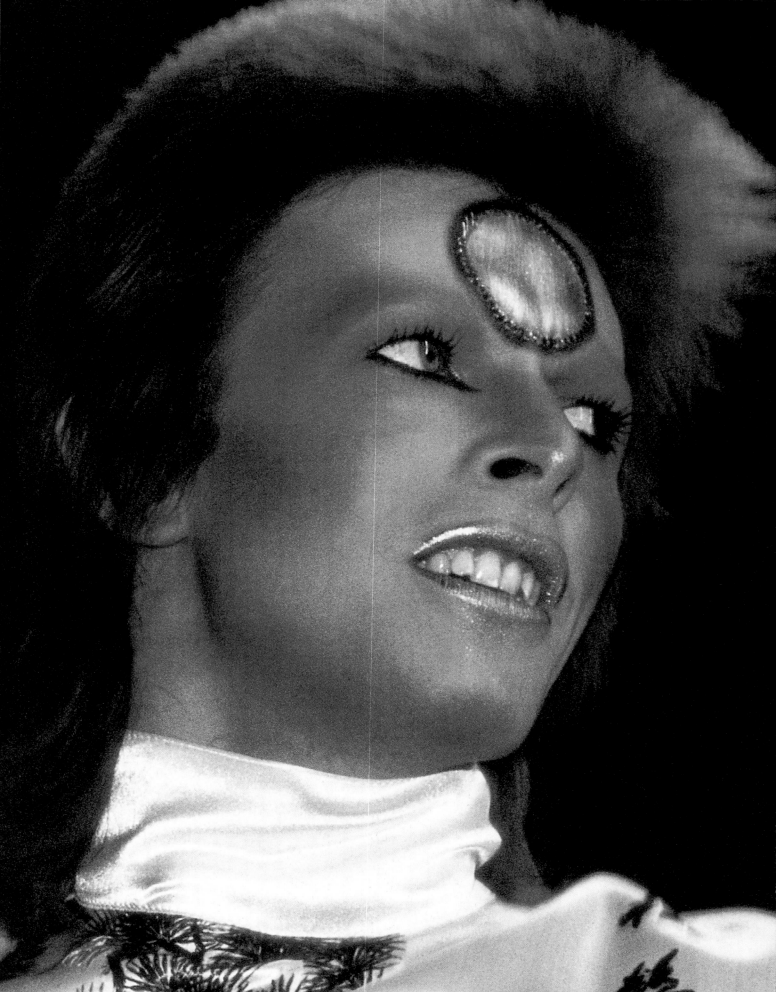

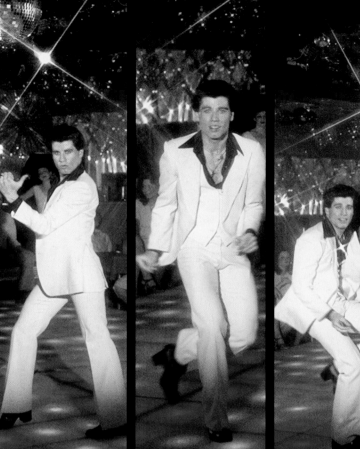
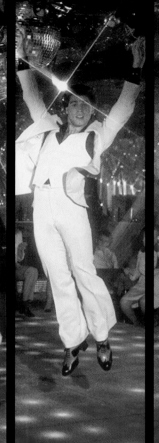

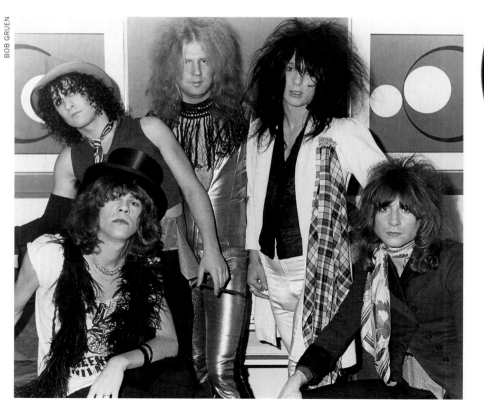

Glam and Glitter

Rock was barely stayin' alive as the Disco Inferno raged and dancers shouted: "Burn, baby, burn!"

DAVID BOWIE has been rock's foremost chameleon. Here, in '73, he is Aladdin Sane. John Travolta, as a Brooklynite who lived to trip the light fantastic on the weekend, showed how to seduce a dance floor in the Bee Gee–studded *Saturday Night Fever*. The New York Dolls were puttin' on the ritz from 1971 to '75, miles ahead of their time.

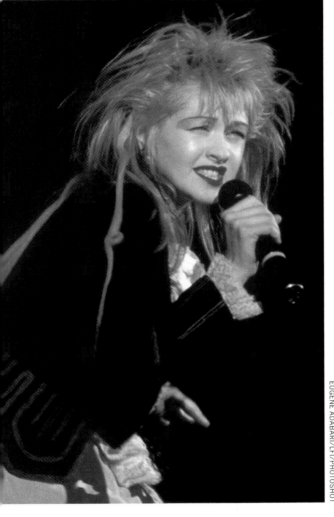

EUGENE ADABARI/LFI/PHOTOSHOT

New Wave Punks

Some were power popsters, some were punk poseurs, a few were truly dangerous.

IN LIVELIER MOMENTS, Patti Smith (below) helped jump-start a rock revival that was all about rebuttal. In the aftermath of the fatal disaster involving Sid Vicious and his girlfriend, Nancy Spungen, nothing seemed outrageous. After Sid was charged with killing her in 1978—and then OD'd himself—such far-out characters as Cyndi Lauper (left) appeared benign.

LYNN GOLDSMITH

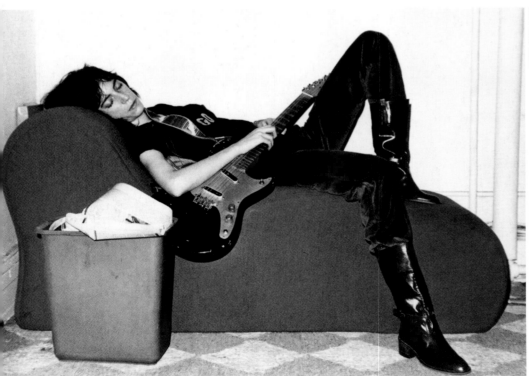

DENNIS MORRIS/CAMERA PRESS

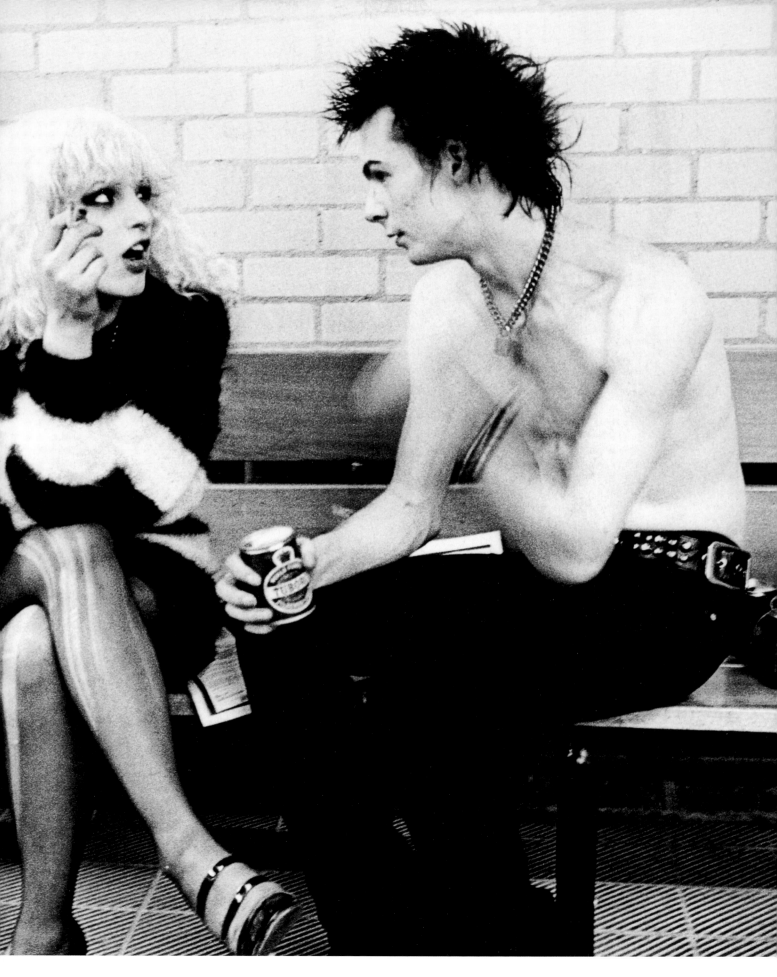

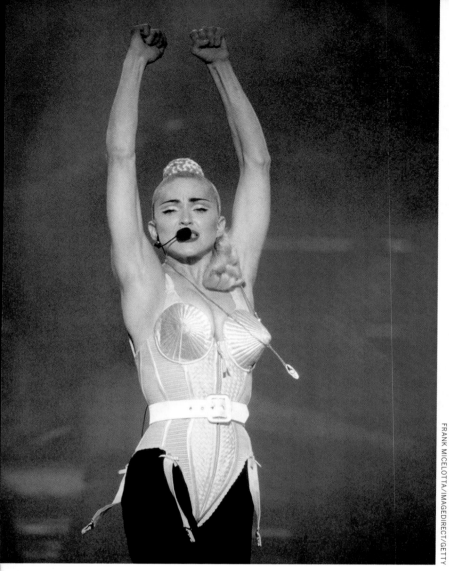

FOR QUEEN and Journey and Genesis, it was power anthems that could reach the far end zone of a football field. For Ozzy and Alice and Kiss (below), it was Grand Guignol theatrics writ very, very large. For Bruce (right), it was a four-hour revival meeting sweeping across the land, healing the sick. For Madonna, it was . . . well, you know.

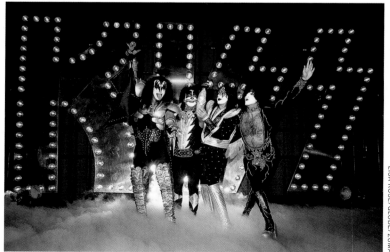

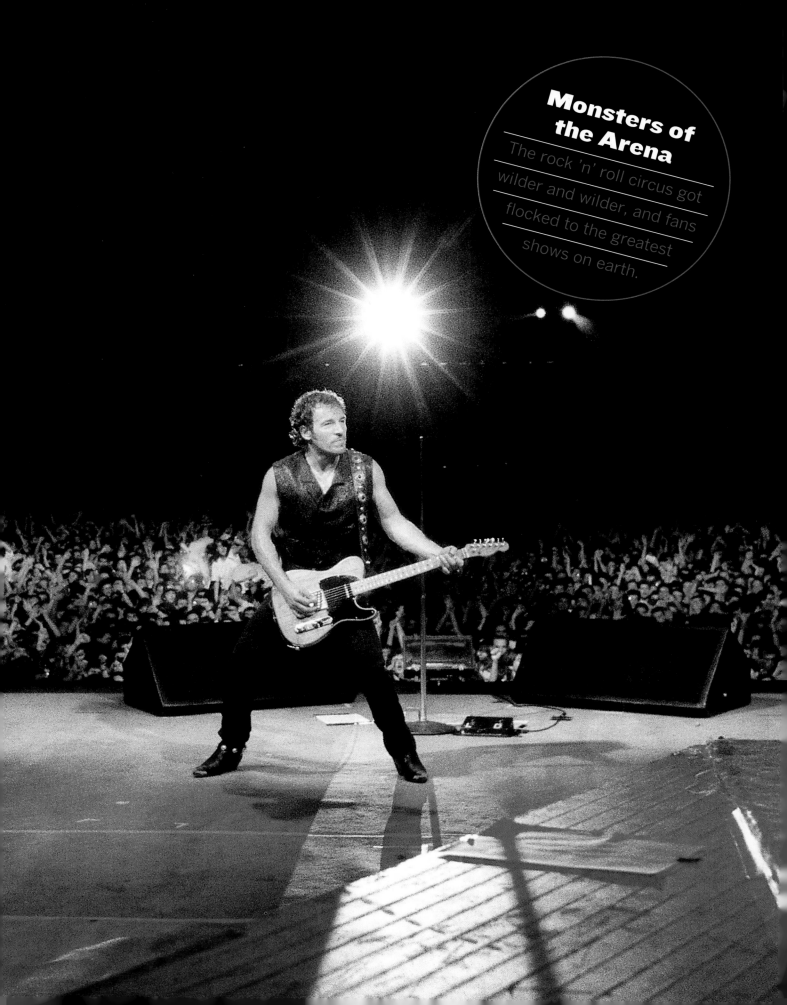

Monsters of the Arena

The rock 'n' roll circus got wilder and wilder, and fans flocked to the greatest shows on earth.

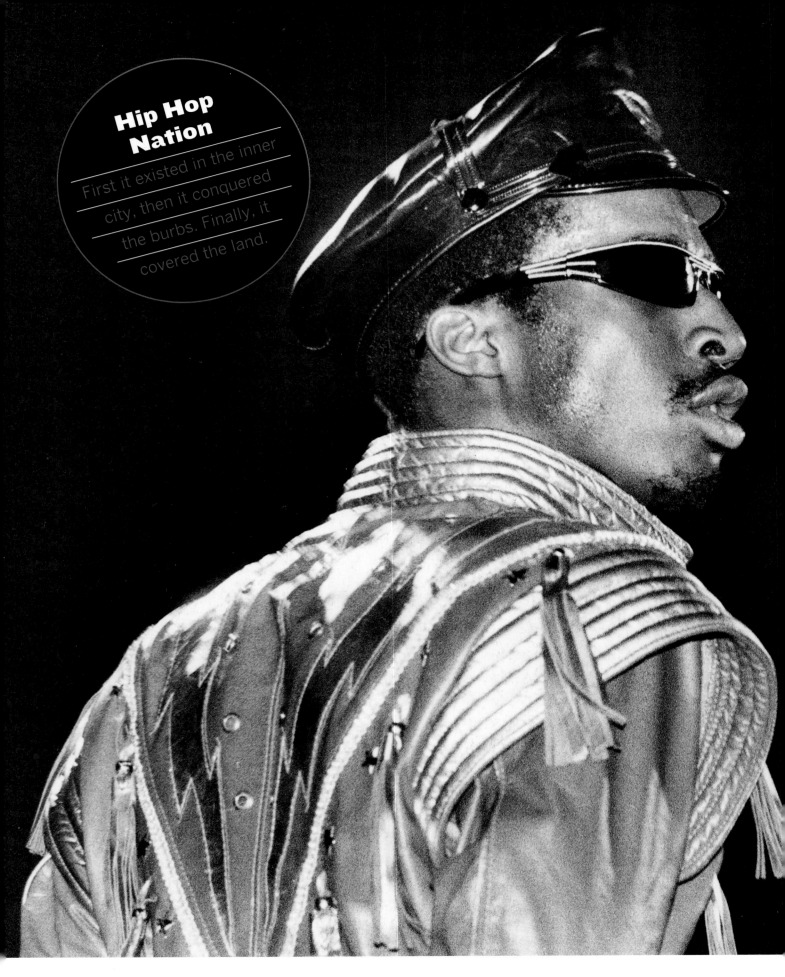

Hip Hop Nation

First it existed in the inner city, then it conquered the burbs. Finally, it covered the land.

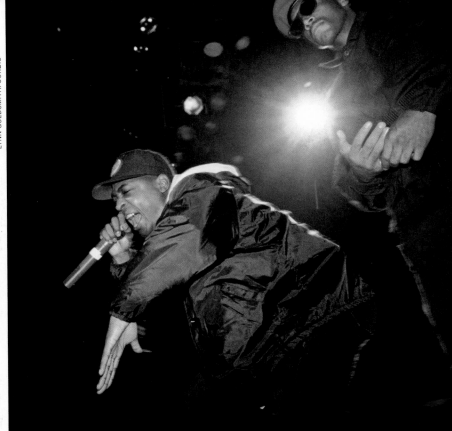

IN THE '70S, Joseph Saddler, who had been born in Barbados but raised in the Bronx, began to master and embellish cutting, a complex art of record-spinning. Soon, as Grandmaster Flash, he assembled a crew that included Melle Mel and released the first record to make sampling important. Above: Chuck D of Public Enemy declaiming. Below: Eminem has long been hip hop's preeminent white rapper.

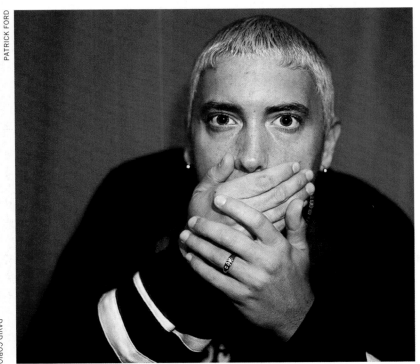

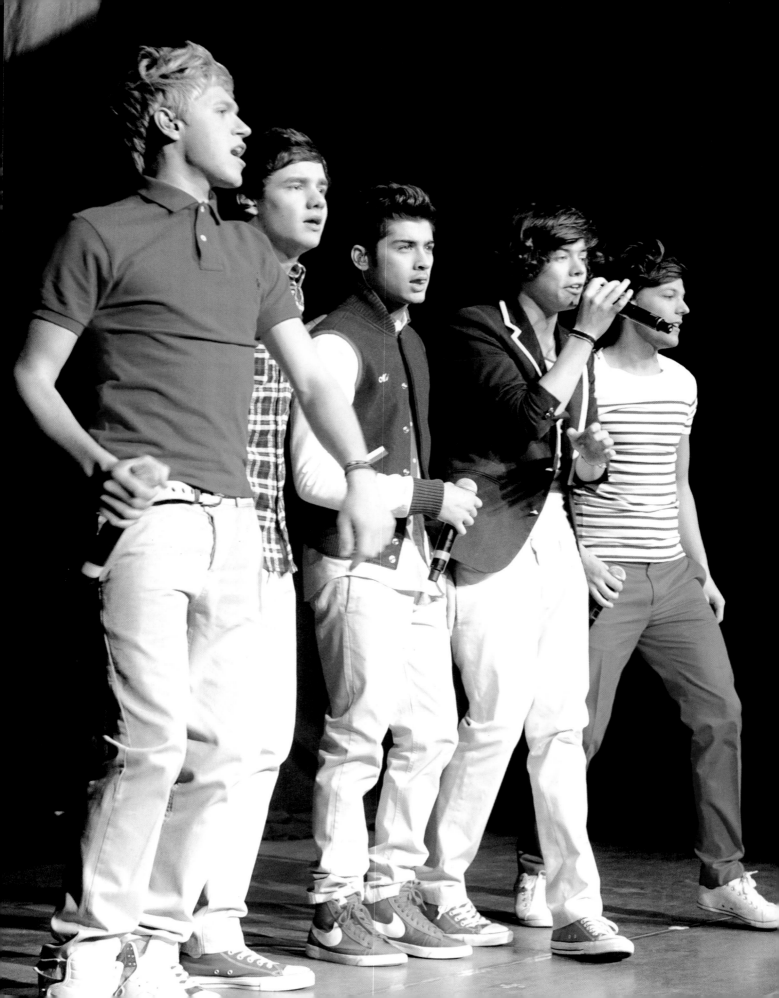

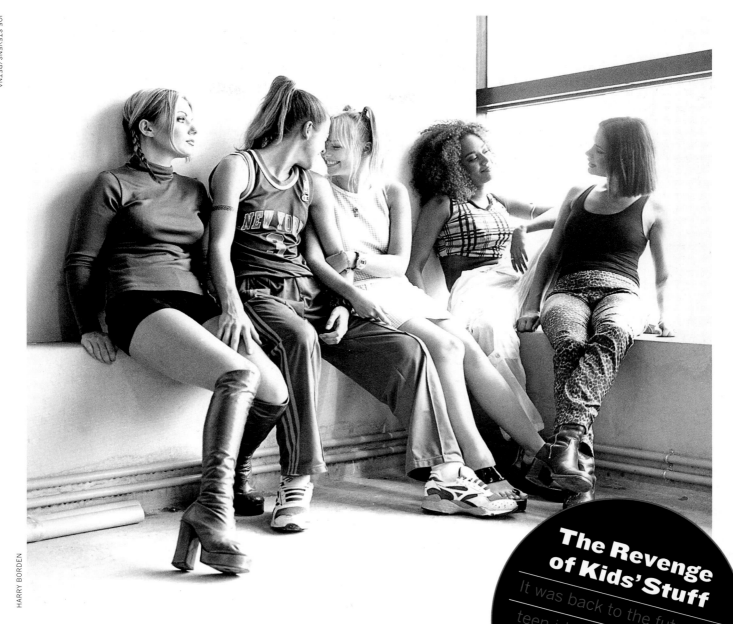

The Revenge of Kids' Stuff

It was back to the future as teen idols again took over the charts—and boys' and girls' hearts.

ROCK 'N' ROLL is music of the young, by the young, for the young, as Dick Clark always understood. His Fabian and Frankie were followed, eventually, by the Spice Girls and the Spears girl, and today we have the latest Boy Band resurgence, with One Direction being exhibit 1A. Ever thus. Ever thus.

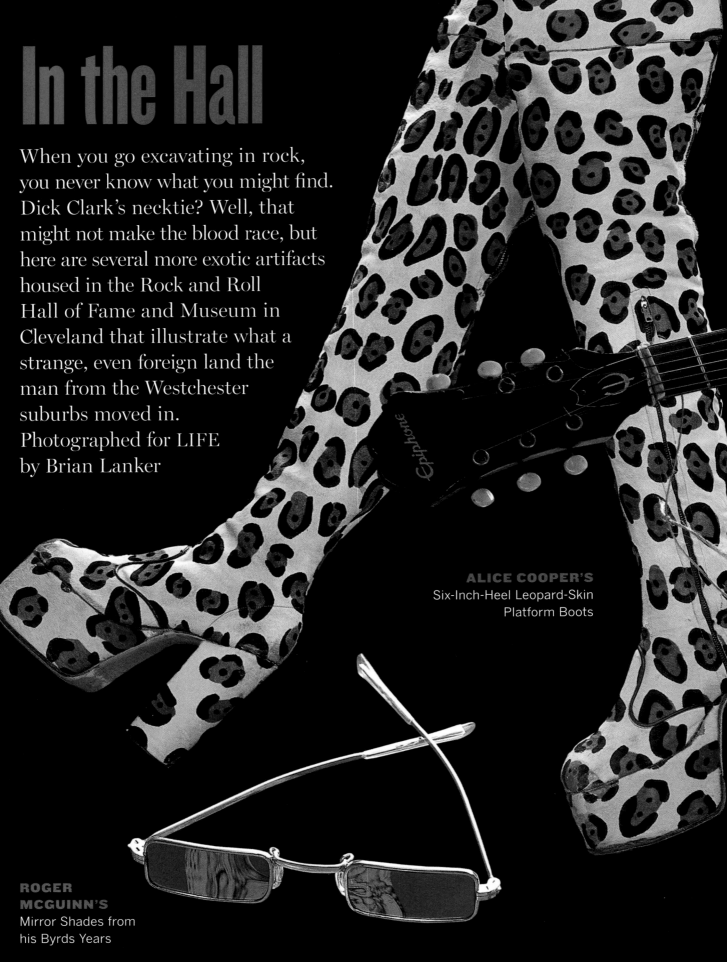

In the Hall

When you go excavating in rock, you never know what you might find. Dick Clark's necktie? Well, that might not make the blood race, but here are several more exotic artifacts housed in the Rock and Roll Hall of Fame and Museum in Cleveland that illustrate what a strange, even foreign land the man from the Westchester suburbs moved in. Photographed for LIFE by Brian Lanker.

ALICE COOPER'S
Six-Inch-Heel Leopard-Skin
Platform Boots

ROGER McGUINN'S
Mirror Shades from
his Byrds Years

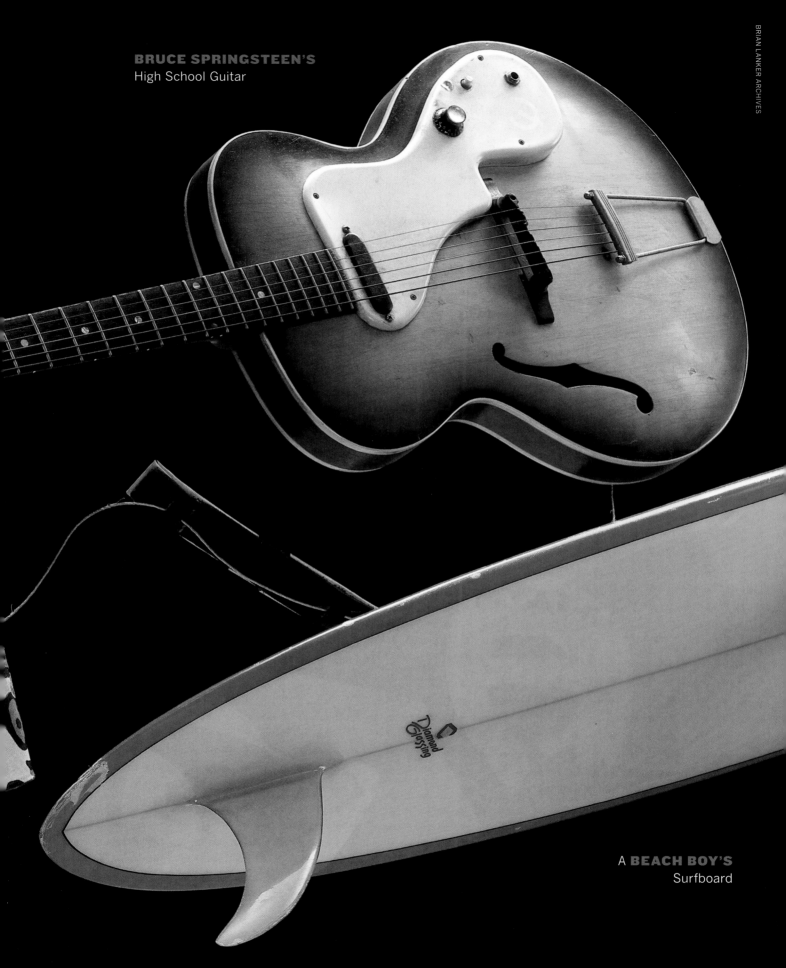

BRUCE SPRINGSTEEN'S
High School Guitar

A **BEACH BOY'S**
Surfboard

Diamond
Glassing

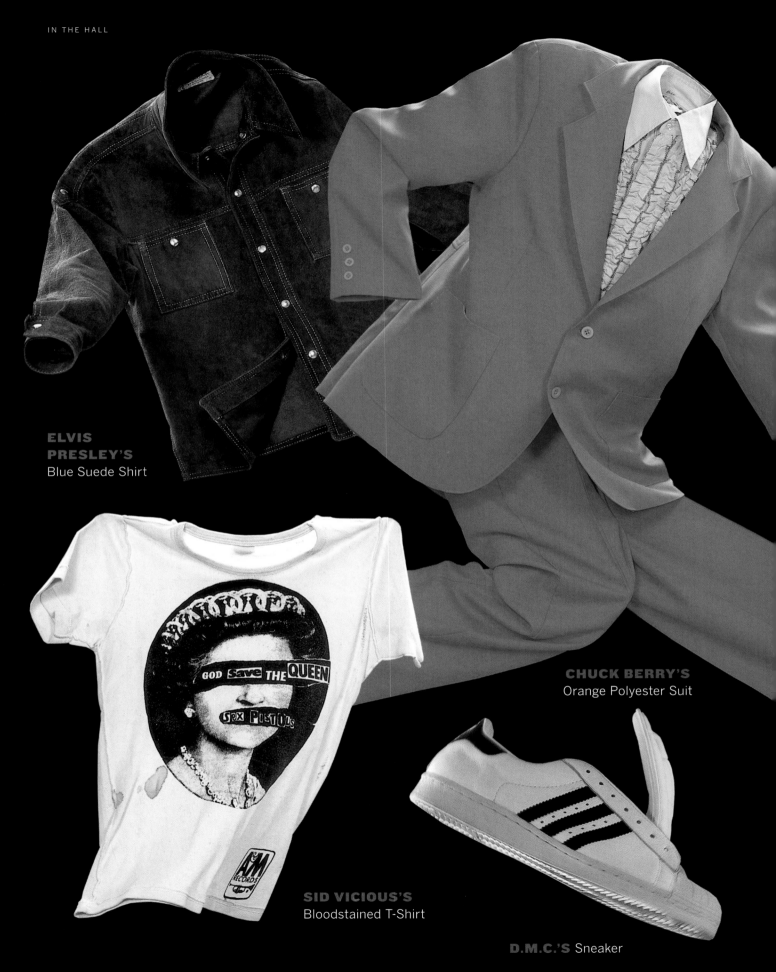

ELVIS PRESLEY'S
Blue Suede Shirt

CHUCK BERRY'S
Orange Polyester Suit

GOD Save THE QUEEN
Sex Pistols

A&M RECORDS

SID VICIOUS'S
Bloodstained T-Shirt

D.M.C.'S Sneaker

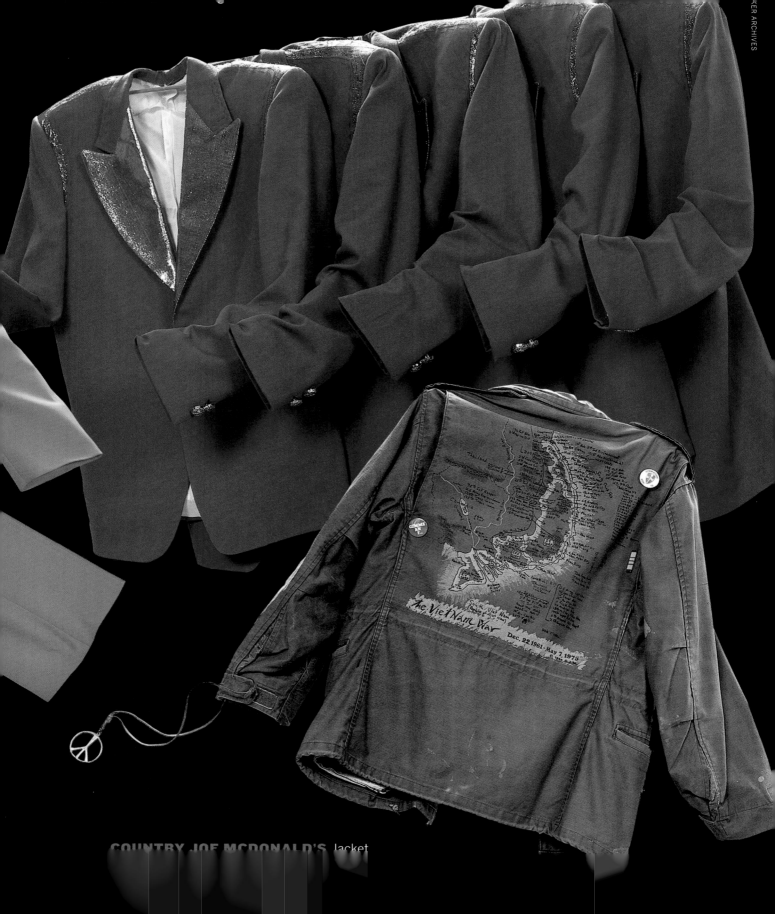

COUNTRY JOE MCDONALD'S Jacket

COUNTRY JOE MCDONALD'S Jacket

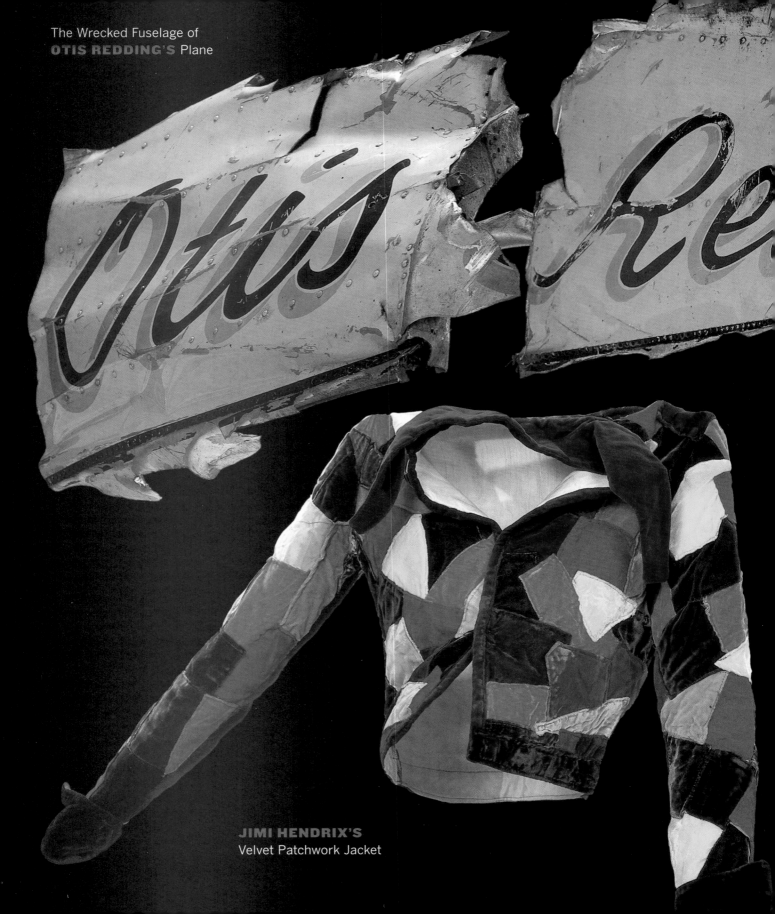

The Wrecked Fuselage of
OTIS REDDING'S Plane

JIMI HENDRIX'S
Velvet Patchwork Jacket

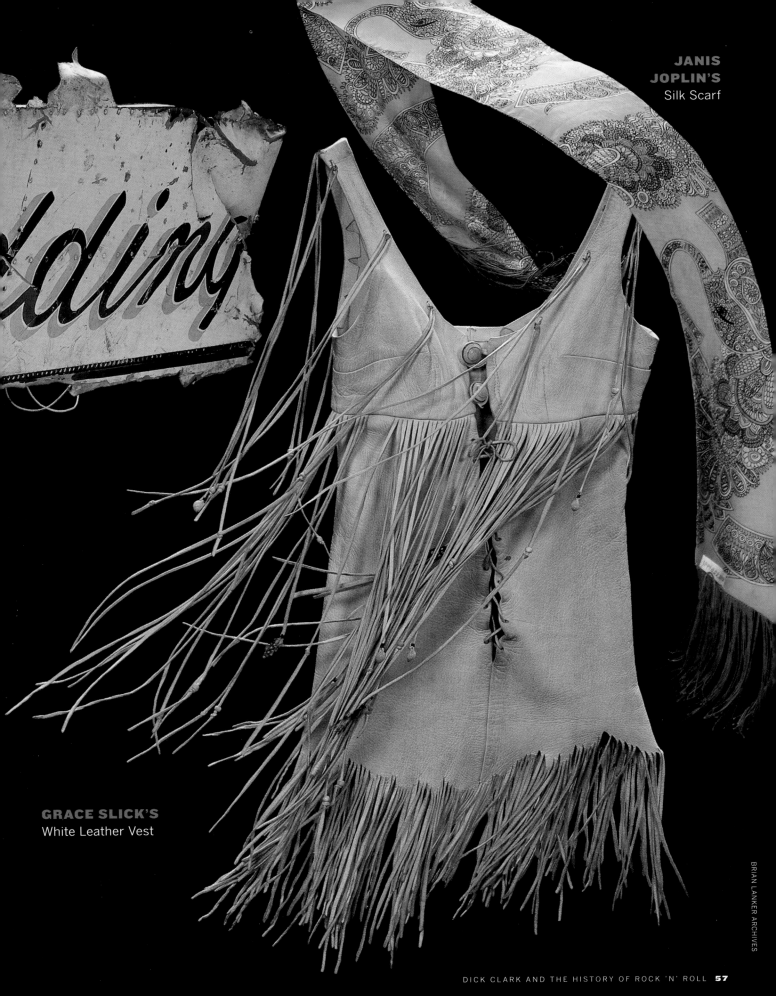

JANIS
JOPLIN'S
Silk Scarf

GRACE SLICK'S
White Leather Vest

BRIAN LANKER ARCHIVES





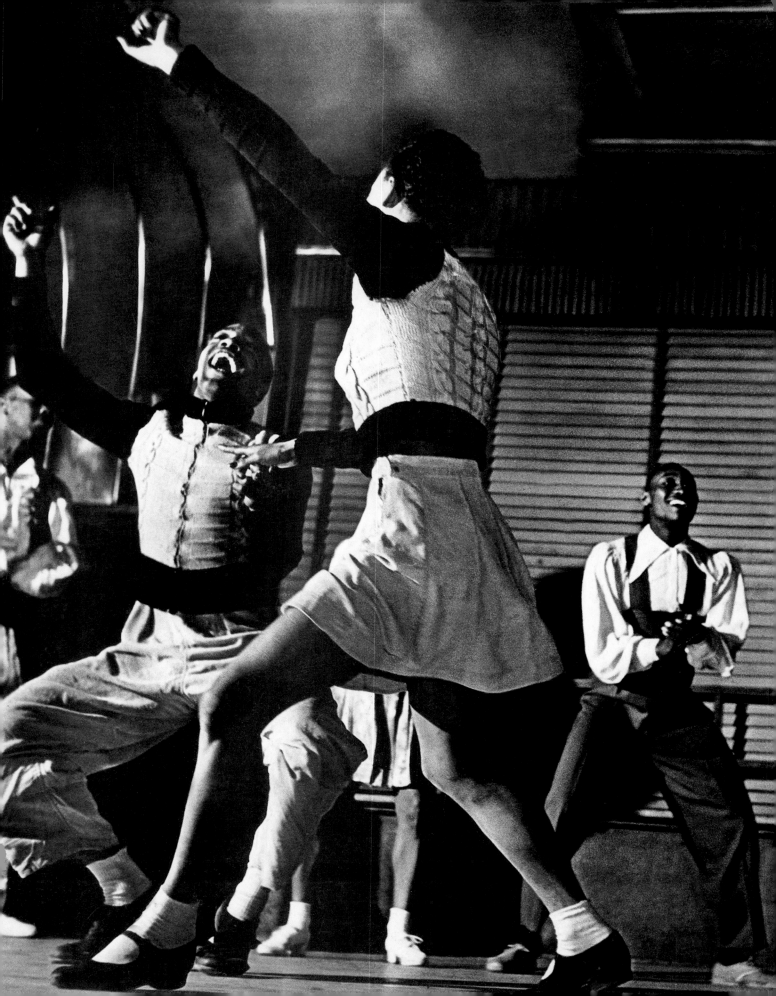

"It's Got a Good Beat and You Can Dance to It"

As Dick said, the kids at *Bandstand* simply had to dance. He understood: It's half of rock 'n' roll.

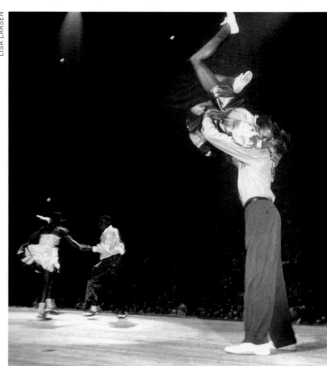

IN THE FINAL YEARS of the Before Rock era, dances such as the Congaroo (left) presaged gyrations to come. It was a very short leap from the Lindy Hop to the rock-fueled Jitterbug craze of the '50s (above).

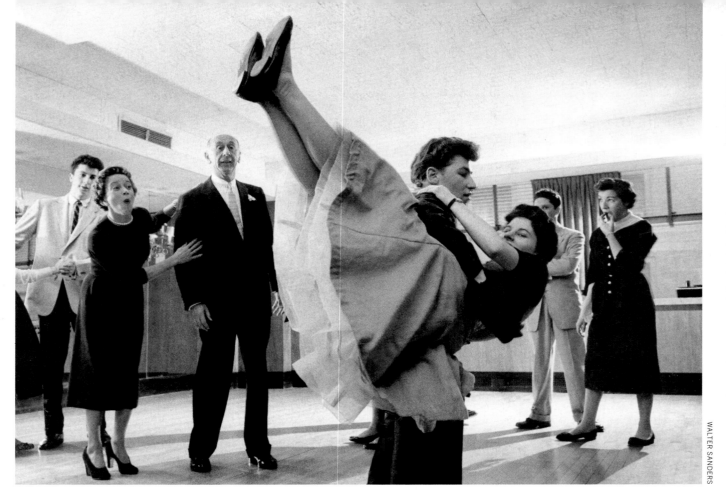

JULIAN WASSER/GETTY

WALTER SANDERS

WE'RE NOT sure what step the dancemeisters Kathryn and Arthur Murray were teaching here, but it seems likely that the folks above got their money's worth. The first half of the '60s was a hotbed of dance crazes, and the Twist was the nonpareil. It could be rudimentary on the beach or Wallenda-like indoors. Needless to say, it was featured daily on *Bandstand.*

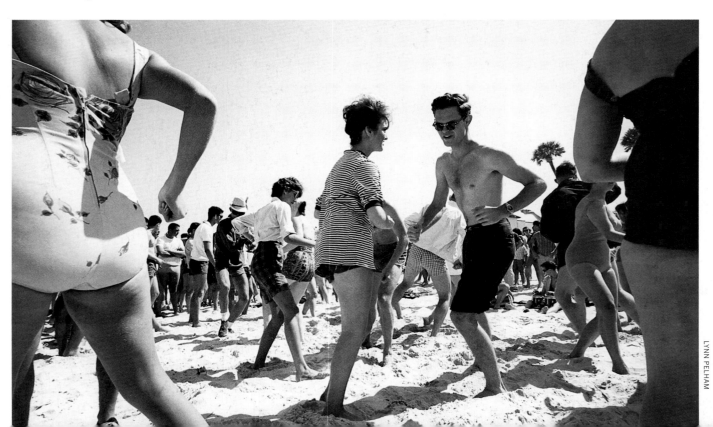

LYNN PELHAM

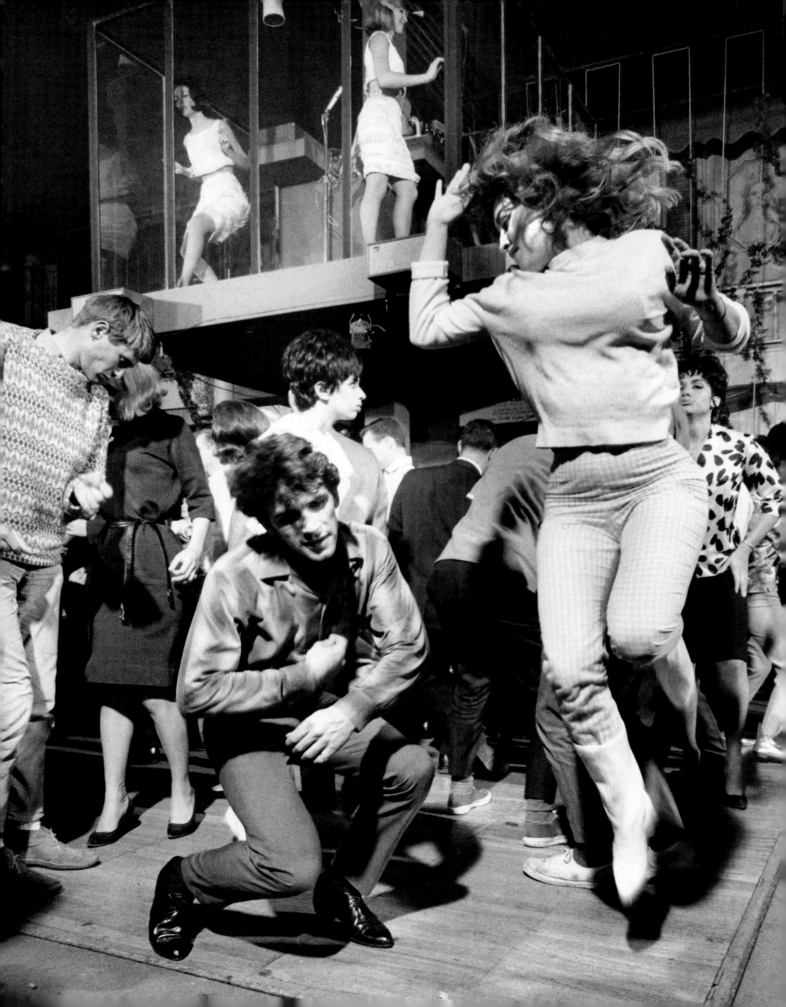

AS THE '60S continued, young people were beginning to "do their own thing." This freedom extended to the realm of dance, which meant that you could do whatever you wanted and it would qualify as dance. The people above were groovin' to some happenin' music in 1969 at the original Woodstock. By the mid-'70s, however, it was again time for terpsichoreans to embrace, which disco—albeit not for all tastes—made compulsory, as here at New York City's Studio 54.

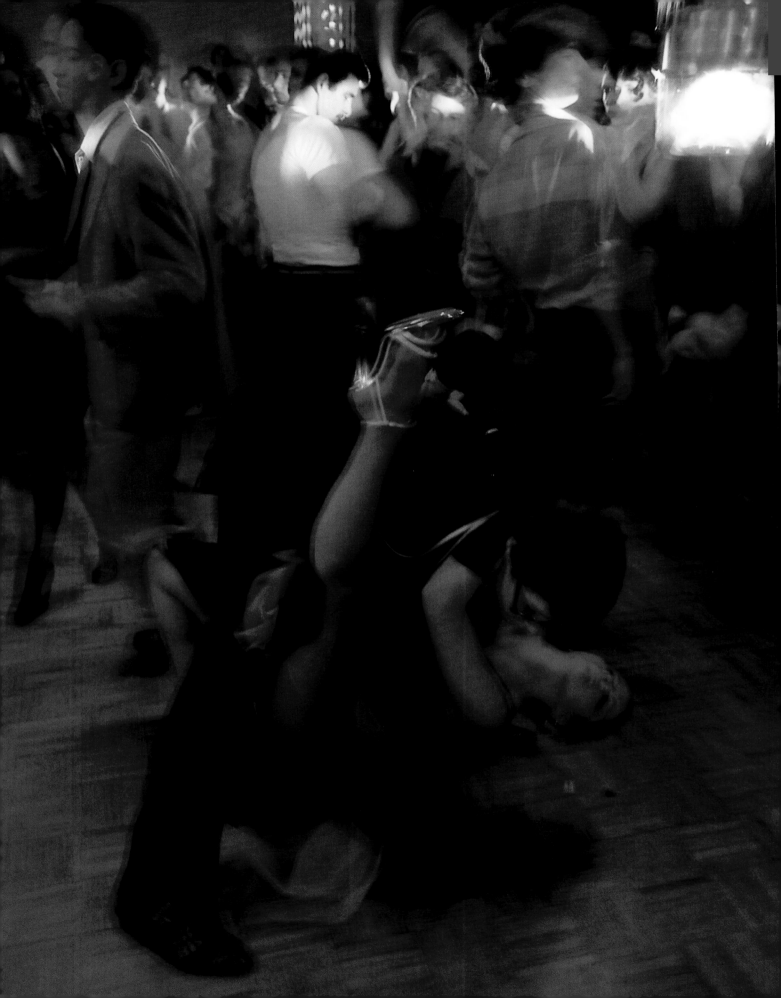

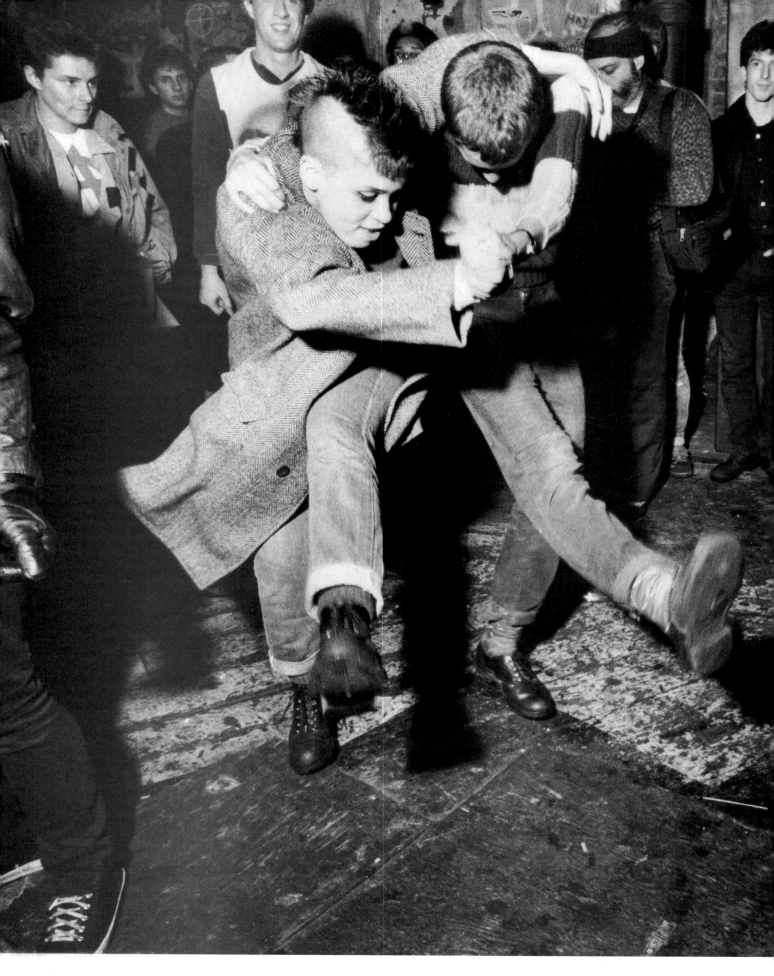

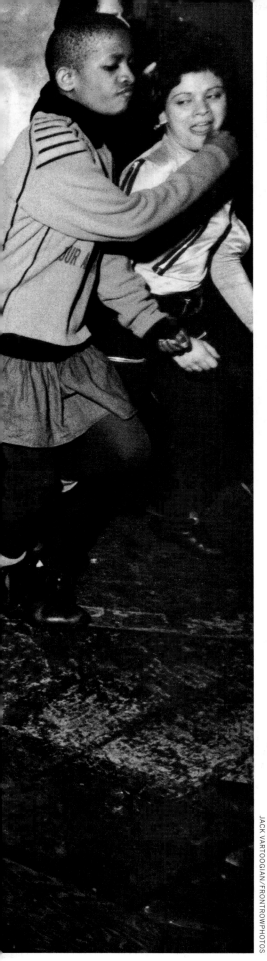

LYNN GOLDSMITH

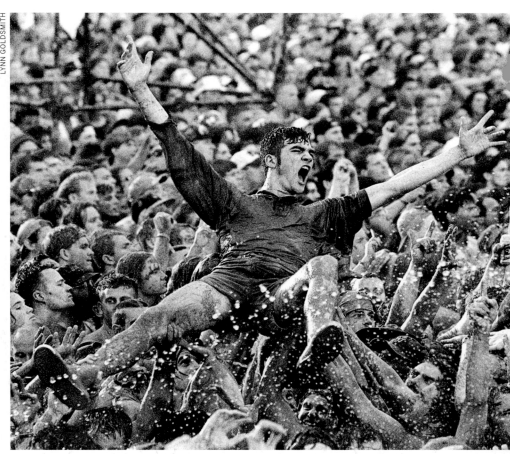

JACK VARTOOGIAN/FRONTROWPHOTOS

BEGINNING IN the '70s, and certainly in violent reaction to the tight rules of disco, things got way out of control. Punks at New York's CBGB (left) and in similar clubs in L.A. and London stomped and pogoed the nights away. Also of urban origin was break dancing (right), practiced in a club, a gym or on the sidewalk. In later years, you needed some room for a decent mosh pit; never was there more space than at Woodstock II in 1994, where the mud pit was measured in acres.

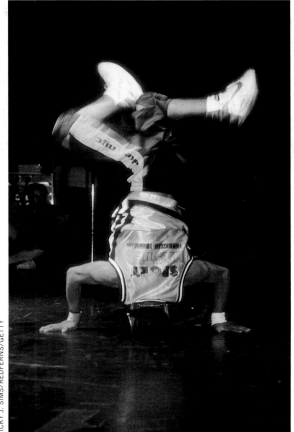

NICKY J. SIMS/REDFERNS/GETTY

Rockin' the Box

Radio was rock's medium when Clark discovered it, but—with his considerable help—rock would play on TV too, boosting Elvis and the Beatles, making the Monkees and even Miley.

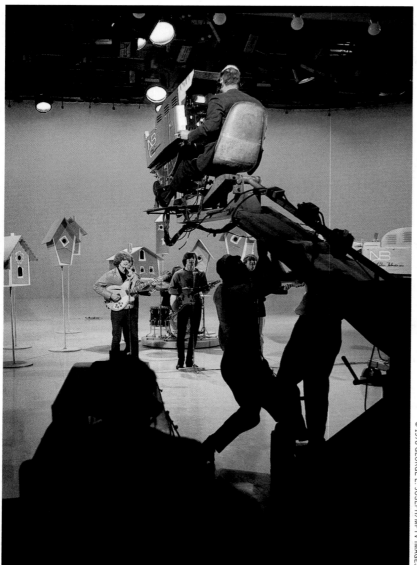

© 1978 GEORGE E. JOSEPH/MPTV IMAGES

SEEING IS BELIEVING: Dick Clark started bringing rock 'n' roll to the nation in 1957. Teens could check out the latest acts, and the latest steps. Similar local afternoon shows sprang up around the country, usually with meager budgets and sparse sets. In the mid-'60s, NBC had a nocturnal *Hullabaloo* (above). Here, the Byrds are in their element.

PAUL SCHUTZER

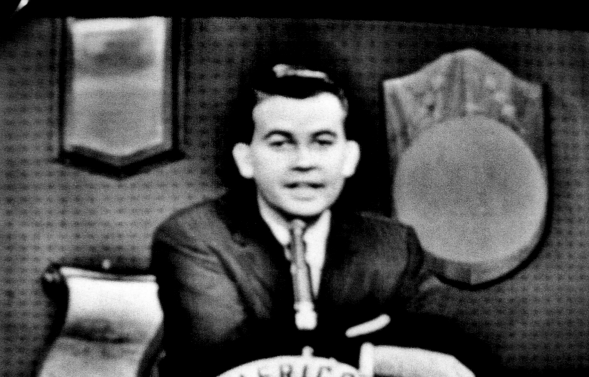

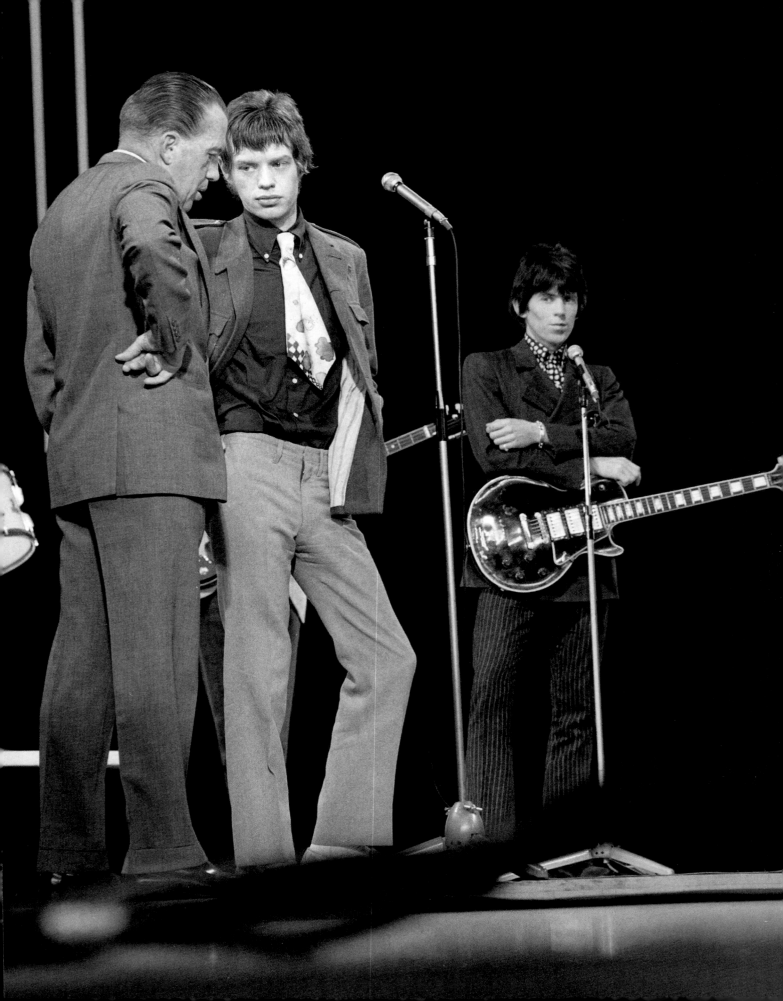

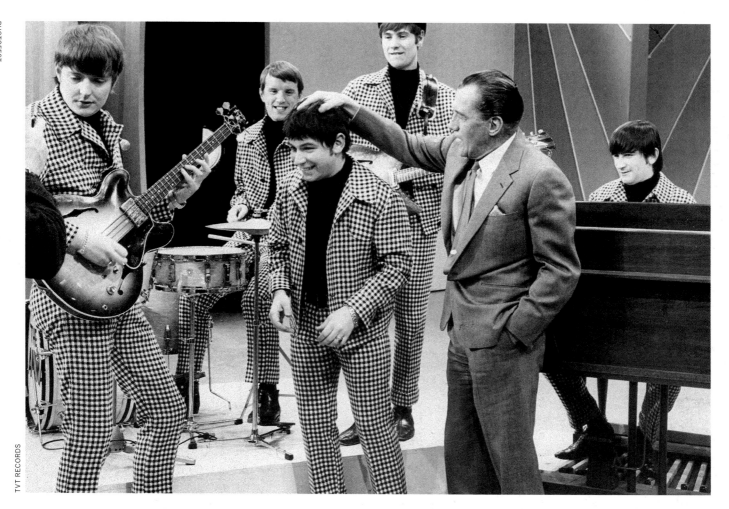

A REALLY BIG SHEW: When Ed Sullivan saw the ratings Elvis drew for Steve Allen, he began a long practice of booking rock's biggest talents. Clockwise from left: Ed chats with Mick Jagger and a wary Keith Richards; Old Stoneface clowns with diminutive-but-big-voiced Eric Burdon and the besuited Animals; the King has an audience with bedazzled subjects; the Beatles (sans George) and manager Brian Epstein give a lesson.

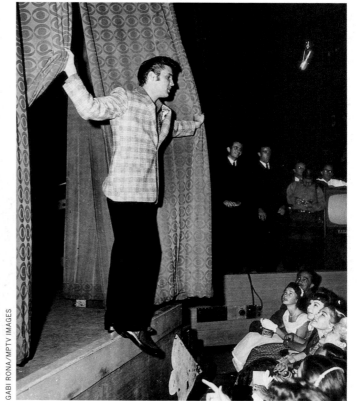

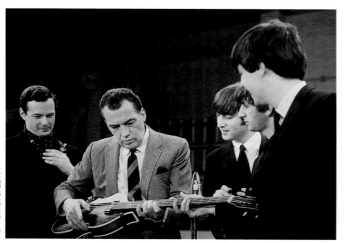

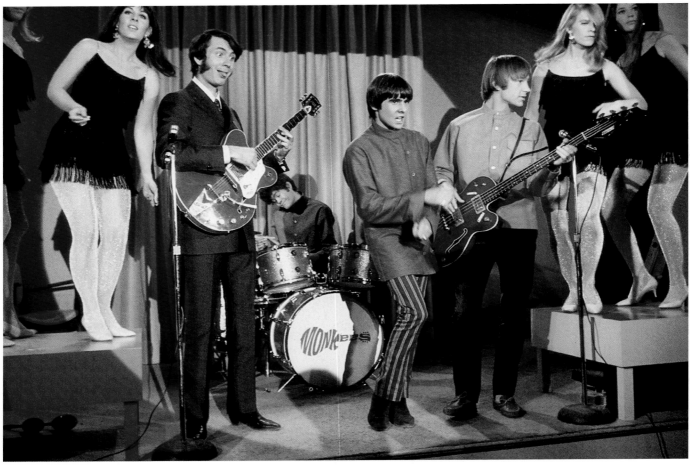

THE BEAT GOES ON: The Monkees were a poor man's Beatles, fabricated for the tube. Sonny and Cher had fun, and a good run, with their variety show. On *Hullabaloo*, Johnny Rivers sang one of his many hits.

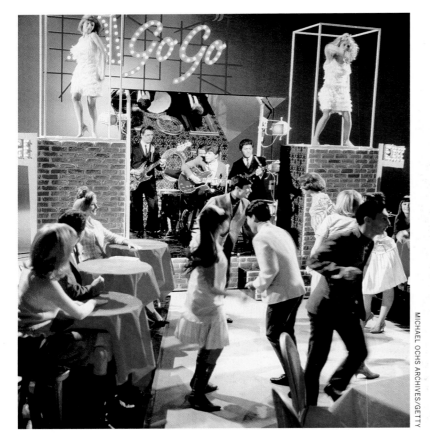

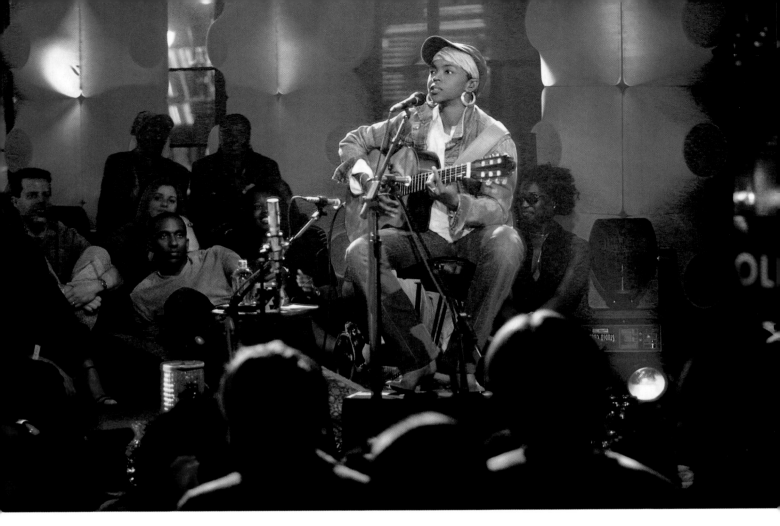

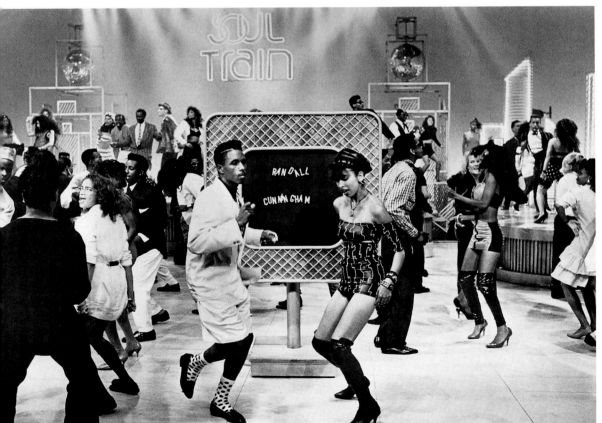

It Wasn't Always Pretty

On the big screen, there were classic rock docs, the high spirits of *A Hard Day's Night* and the sharp satire of *This Is Spinal Tap*. Then there were Elvis's 31 films—not to mention Dick's!

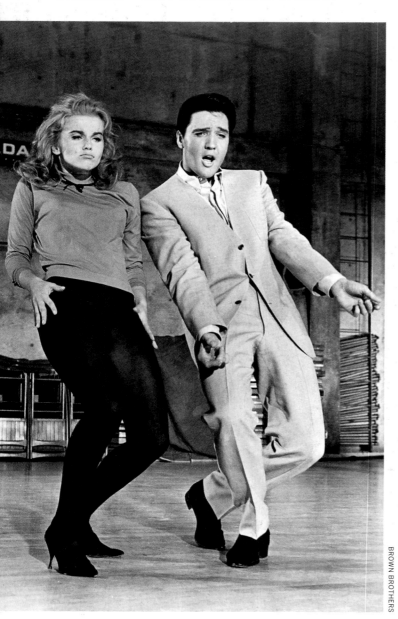

KILLER COUPLES: Of Elvis's leading ladies, none came closer to matching his charisma and sexuality than did Ann-Margret, his costar in 1964's *Viva Las Vegas.* The heat generated by Annette Funicello and Frankie Avalon in 1965's *Beach Blanket Bingo* was of a considerably less steamy sort.

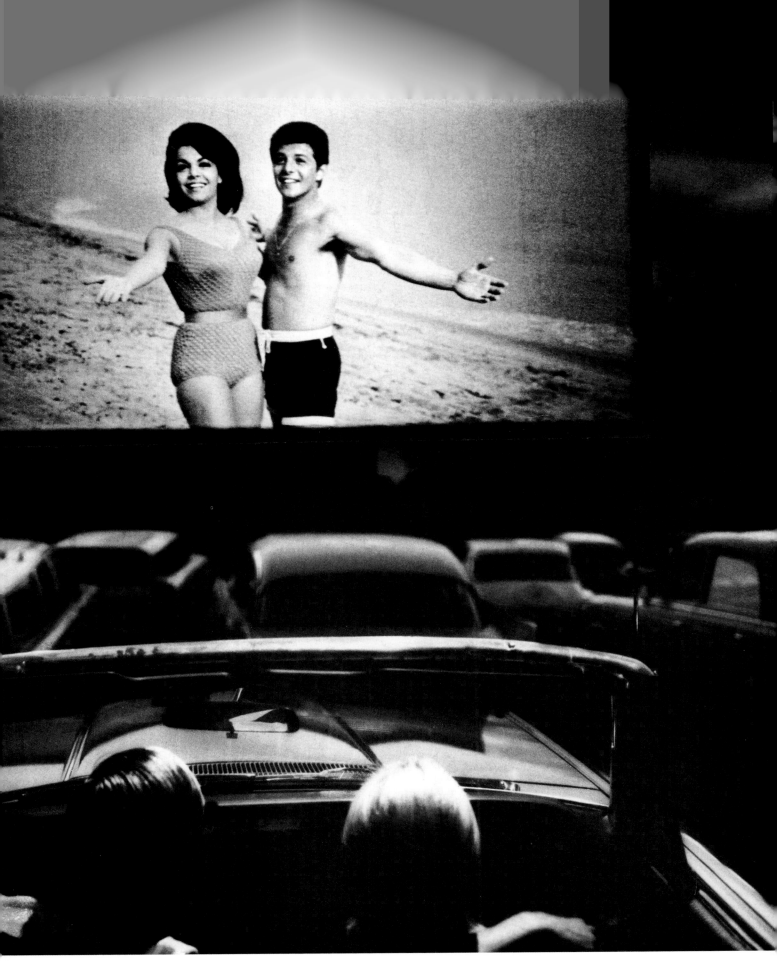

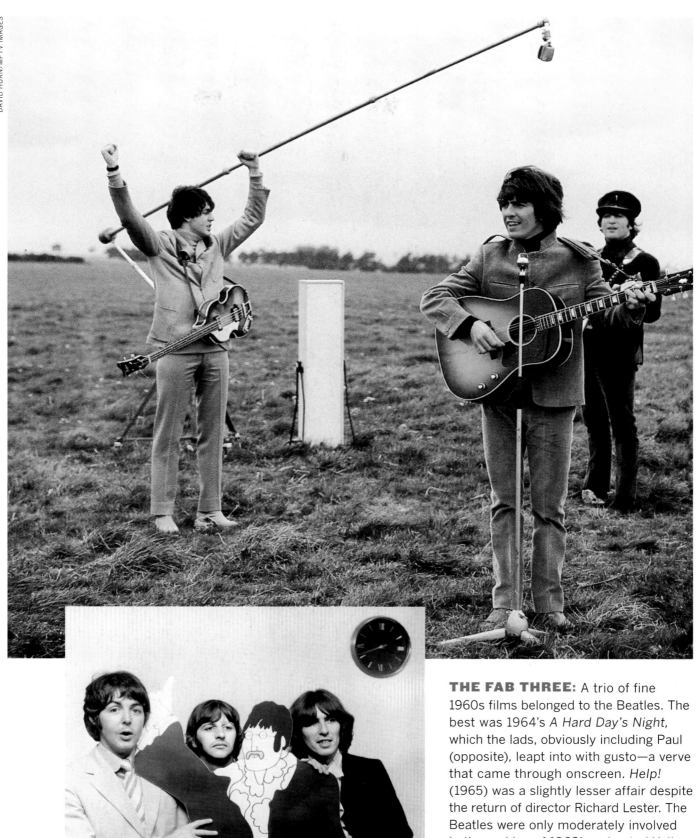

THE FAB THREE: A trio of fine 1960s films belonged to the Beatles. The best was 1964's *A Hard Day's Night*, which the lads, obviously including Paul (opposite), leapt into with gusto—a verve that came through onscreen. *Help!* (1965) was a slightly lesser affair despite the return of director Richard Lester. The Beatles were only moderately involved in the making of 1968's animated *Yellow Submarine*, but were happy to affiliate with the flick when it turned out to be a great cartoon. A 3D version for a new generation has recently been tabled.

ROCKUMENTARIES: *Woodstock* caught the spirit of the 1969 peace-and-love festival in upstate New York. Similarly—if horrifically— *Gimme Shelter* evoked the tension of that same year's Rolling Stones tour and its climactic moment when a fan was killed at the Altamont concert in California.

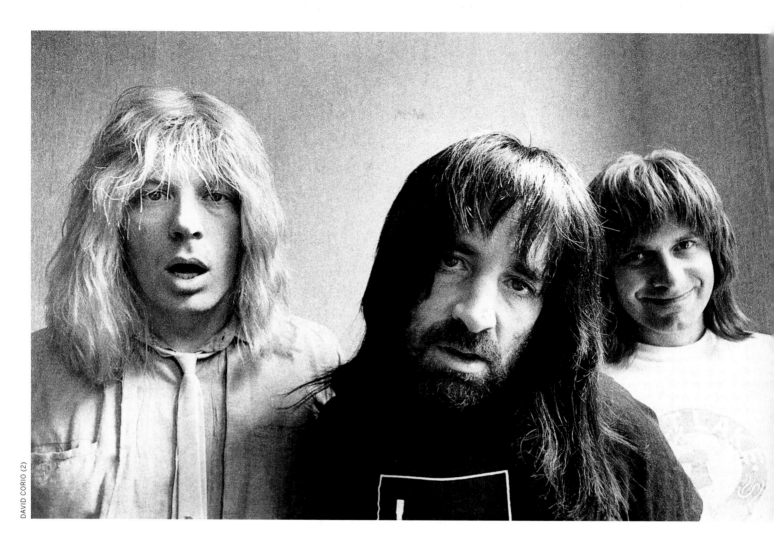

MOCKUMENTARY:
In 1984, comedians Michael McKean, Harry Shearer and Christopher Guest donned wigs and became the front line of the fictitious, ill-starred heavy metal band Spinal Tap. Director Rob Reiner's brilliant satire proved that it is indeed a fine line between clever and . . . stupid.

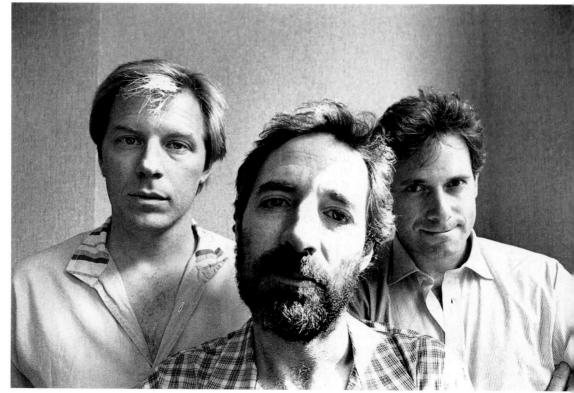

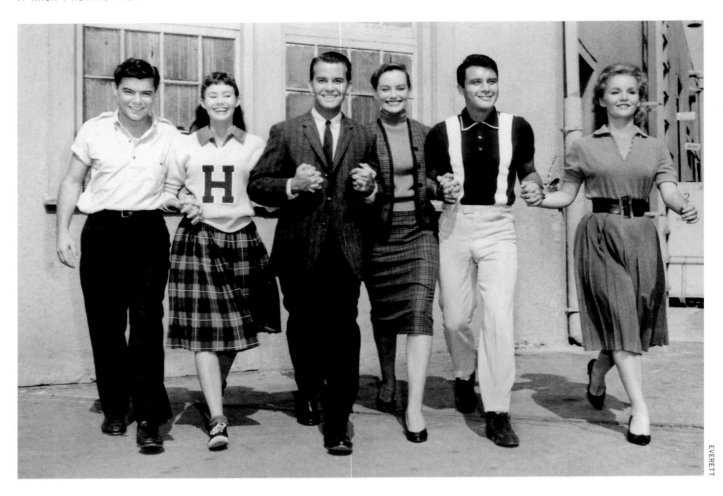

BECAUSE THEY'RE YOUNG Yes, that's why they look happy, and that's why they are parading on the set of the movie of that name in 1960 (from left, above: Warren Berlinger, Roberta Shore, Dick Clark, Victoria Shaw, Michael Callan and Tuesday Weld). Below, in 1959, Dick Clark grooms with actor Edd Byrnes on *American Bandstand*— "Kookie, lend me your comb"—and then, in 1978, Byrnes plays Vince Fontaine, the "Dick Clark character," in *Grease*. Opposite: *Hairspray*'s "Dick Clark character," actor Shawn Thompson, with Ricki Lake in the 1988 film.

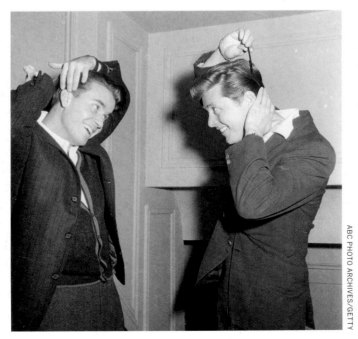

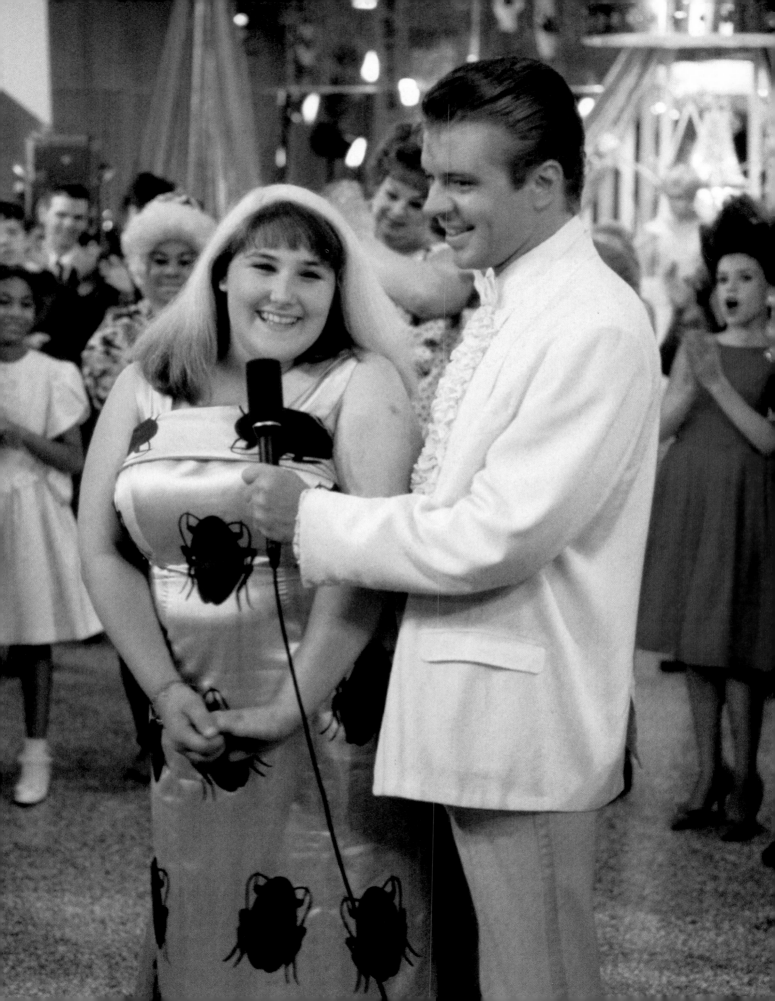

Farewell . . . to a Friend

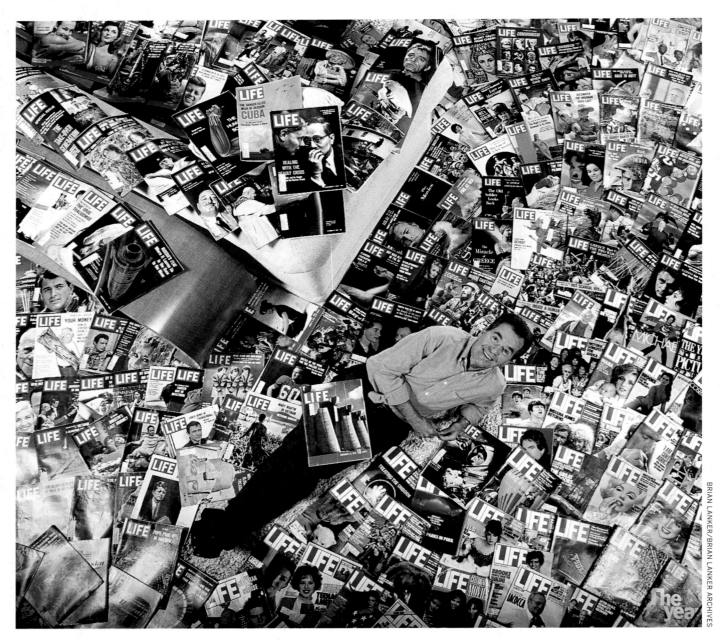

AS YOU MIGHT EXPECT and as is evinced in the pages of this book, LIFE, as the national photographic magazine of record in the 1950s and '60s, and Dick Clark—as . . . well . . . as Dick Clark—crossed paths on regular occasion. It delighted us to learn, later in our relationship, that we had been as important to him as he had been to us. "You had the radio, an occasional movie, but LIFE magazine was there every week," he told us in the spring of 2000, when posing for this photograph. "It brought the world to you right there in your own hands." Clark reminisced, at that time, about spending childhood summers with his grandmother, poring over old issues with her. When she asked what he wanted when she died, there was only one thing—her LIFE collection, which was complete (in his lap is the 1936 premier issue). "It's all there," Clark told us. "You can see the evolution of this country, its changing morals, from innocence to sophistication." The evolution of this country, our sense of sophistication, but also our longing for a certain innocence: all things in which Dick played a crucial role.

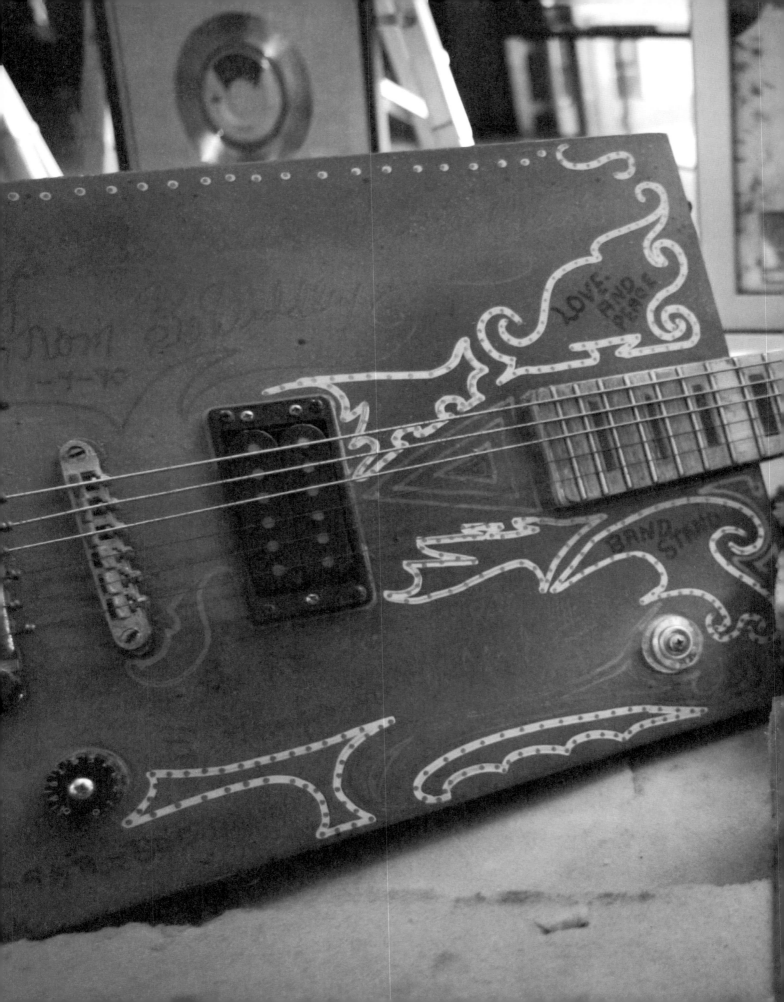